FIVE-MINUTE
WATERCOLOUR

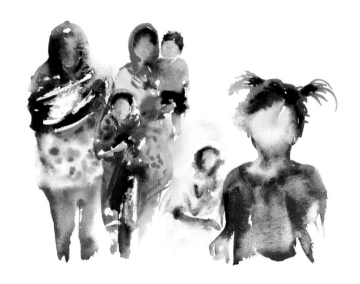

Published in 2019 by Search Press Ltd

Wellwood, North Farm Road,
Tunbridge Wells,
Kent TN2 3DR

Reprinted in 2019

Conceived, designed, and produced
by The Bright Press, an imprint of The Quarto Group
The Old Brewery, 6 Blundell Street,
London N7 9BH, United Kingdom.
T (0)20 7700 6700
www.QuartoKnows.com

ISBN: 978-1-78221-704-6

Publisher: Mark Searle
Associate Publisher: Emma Bastow
Managing Editor: Isheeta Mustafi
Commissioning Editor: Sorrel Wood
Editors: Nick Jones and Abbie Sharman
Design and Cover: JC Lanaway

Printed in China

Image credits
Previous page: Anne-Laure Jacquart
Opposite: Olga Flerova
Cover: Samantha Nielsen

FIVE-MINUTE
WATERCOLOUR

Super-quick Techniques for Amazing Paintings

Samantha Nielsen

SEARCH PRESS

Contents

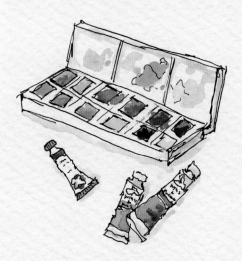

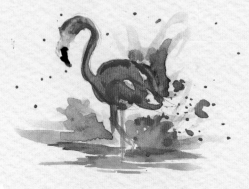

Chapter 3

APPLYING YOUR TECHNIQUES 64

Chapter 4

TAKE IT FURTHER 102

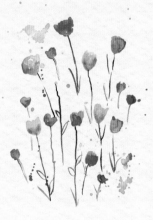

Introduction

Creating a quality painting in a short amount of time might seem impossible, but it is not! You can quickly gain control of a medium that can seem untameable. The key is learning the quick techniques that will turn your watercolour into impressive works of art, and then continuing to practise the skills you learn.

Artwork has been a part of my life since childhood. Growing up, I watched my dad practise his craft at home as well as in the classroom. The ability to create something with your own hands and make the abstract tangible has always fascinated me, and I have had the desire to turn imagery that we see every day into an illustration for as long as I can remember. I have not always been an artist, however, because I did not always think I was capable.

When I was introduced to the world of urban sketching and watercolour, I felt like my heart had finally found its place in the art world and knew this was something I wanted to pursue. While urban sketching is something that

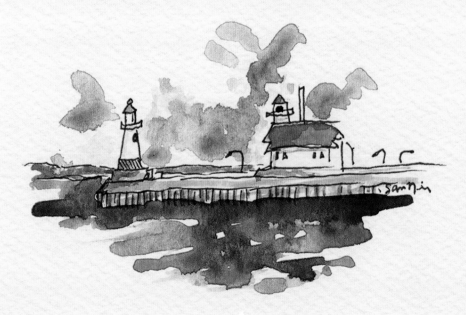

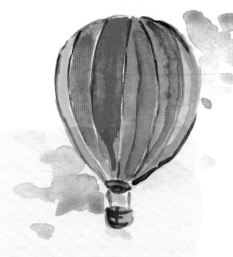

is a huge part of me and my journey – and at times throughout this book you will see that influence – creating fast watercolour paintings with easy and accessible techniques is the focus throughout.

My hope is that by going through these pages, you will understand that it is possible for anyone to pick up a paint brush and create beautiful watercolour works with a wide variety of subject matter in limited amounts of time. Even though some paintings within these pages took a little longer than five minutes, the techniques that are demonstrated and the skills discussed will help you create successful watercolour paintings at speed.

In Chapter 1 we will look at the tools that are necessary to create a quick watercolour painting, as well as discuss what some of those tools are capable of. Chapter 2 will go over some of the most common and beginner watercolour techniques. These techniques can also be achievable in a short amount of time. Chapter 3 takes the basics and turns them into something applicable to the world around us. You will learn how to not only apply techniques but also develop skills for recognising which technique works best in each scenario. Lastly, Chapter 4 focuses on understanding the importance of growing with your materials. We will talk about how much can be achieved with colour, how to capture movement, as well as how to incorporate new and exciting materials into your work.

The best way to learn how to create fast watercolour paintings is to practise. Five minutes a day will add up to hundreds of hours over the course of many years; all you need to do is start! Happy painting!

Samantha Nielsen

Opposite and above **Samantha Nielsen,**
Canal Lighthouse and *Hot Air Balloon*,
Duluth, Minnesota, USA, 2017.
Both of these paintings were created using watercolour techniques that lend themselves to fast painting.

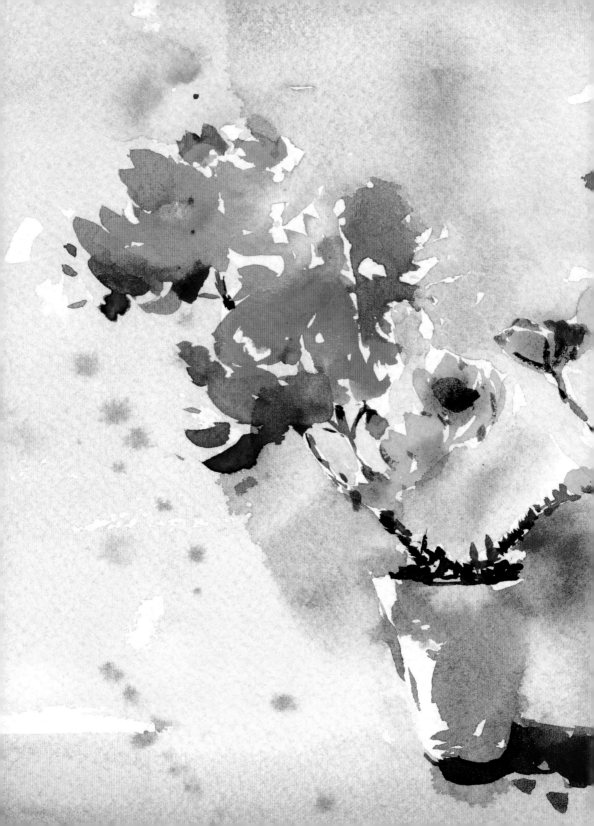

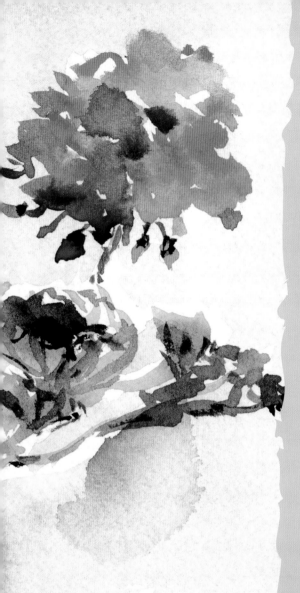

Tools

Starting a new hobby or practising a new skill can be difficult without background information. The numerous options that fill an art shop can be daunting, especially for a beginner. Creating beautiful watercolour paintings in five minutes becomes much easier when you start off using the right types of tools. This chapter introduces several of the materials that will make five-minute watercolour an easier process. Everyone has favourite brands and styles, but finding which ones work best for you will be easier when you know what the options are.

Evelyn Yee, *Geranium*, 2017.
Over time, artists discover their own favourite materials through trying different varieties. Test out new materials to discover what works best!

Right **Samantha Nielsen,**
Colour Wash.
Minimising the number of colours used in a painting will allow you to think faster and not waste time trying to find the perfect colour.

Below **Samantha Nielsen,** *Pines,* **Duluth, Minnesota, USA, 2017.**
There are no more than four or five colours used in this painting. Creating a limited palette will help you focus on the subject matter.

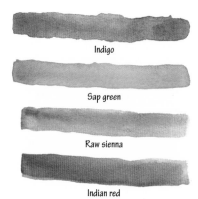

Indigo

Sap green

Raw sienna

Indian red

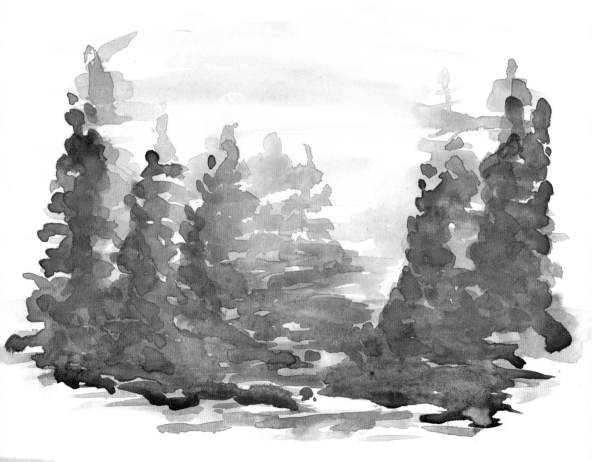

Portable paint

Using paint in a portable way does not mean you have to be 'on the go'. There are many ways paint selection can help in achieving quick watercolour paintings, even at home. Though the number of paint options can be overwhelming, knowing some of these tricks will help when selecting portable paints.

5 portable paint tips

Tube or pan? Paint in the tube is just what it sounds like; it is in a tube. Paint in a pan usually comes as a set and is already in a palette. There is no right or wrong. Paint in a pan can be helpful for beginners because everything is already set up, while paint in a tube lets you be very selective in which colours you want in your watercolour set.

Minimise colour choices Regardless of which type of paint is used, having a limited selection of colours will help make the painting process quicker, especially if you are a beginner watercolourist. Having a limited selection will also help make the process of learning to paint quickly less overwhelming.

Less can be more Limiting selection of colour can actually help an artist grow. Try choosing only four colours and see what can be painted. An artist can capture the essence of a scene without matching every colour exactly.

Try different brands Everyone has different tastes when it comes to watercolour paints. Test out both tube and pan paints. Try colours that are very vibrant and others that are more subtle. Over time, colour choice can help with the development of an artist's individual style.

Keeping paint clean In order to get the most out of watercolour paint, it is important to apply clean water to each colour. Having two water glasses (one to rinse a brush, one to wet paints) will ensure the pigment stays vibrant and fresh.

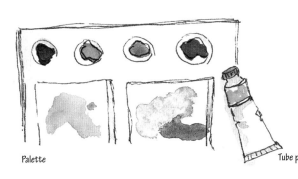

Palette

Tube paint

Left **Samantha Nielsen,**
My Palette, **2018.**
Paint comes in all varieties of colour, quality and style. Buying paint in a tube or in a palette are both effective when trying to achieve quick paintings.

Paper

The kind of paper artists use can make a huge difference to the outcome of their artwork. Each variety of paper has different characteristics and will react with watercolour paint differently. Here are a few things to consider when deciding on the best fit for creating five-minute watercolour paintings.

5 pointers for paper

Types of paper There are three main types of watercolour paper: hot press, cold press and rough. Hot press has a very smooth surface; cold press has some 'tooth' or texture; rough has even more texture.

Paper traits Brushstrokes will show up more on hot press, but it can also present some trouble for beginners, as it is hard to blend the paint without it becoming streaky. Think of cold press as having tiny divots that hold the paint in certain areas. Cold press can be a great paper for beginners, as it allows for more blending and is perfect when initially learning how to handle paint.

Best for speed Quick watercolour painting is easier on cold press and hot press than on rough paper. Because rough paper can hold a lot of water, it will also take more water and pigment to create darker values. This makes achieving fast paintings more difficult, since the brush will need to be more saturated.

Narrowing down the options Most paper falls into two categories: student quality or artist quality. Student quality will work just fine, but as you grow as an artist it is worth investing in artist-quality paper to see the true potential of the paints.

Compare varieties There is no better way to learn about a material than testing it out. Try painting a similar image on hot press paper and then cold press. Pay attention to how applying the paint feels, and notice the difference after the paint dries.

Right **Samantha Nielsen, *Paper Textures*.**
The 'tooth' of watercolour paper determines how the paint will move, mix and react. Hot press has the least tooth; rough the most. Experiment on all three to see the different effects the paper can have on your painting.

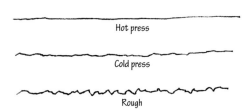

Hot press

Cold press

Rough

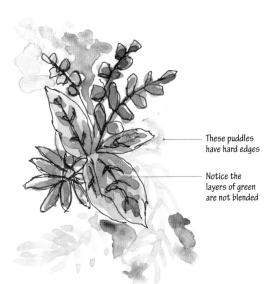

These puddles
have hard edges

Notice the
layers of green
are not blended

Hot press paper

Left & below **Samantha Nielsen,**
Floral on Hot and Cold, 2017.
The first image was done on hot press
paper; the second on cold press. You
will notice the most difference in the
leaves because the paint lies on the
paper a little differently.

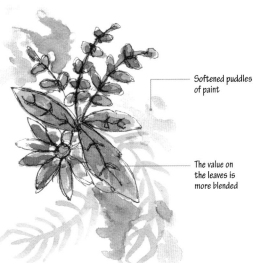

Softened puddles
of paint

The value on
the leaves is
more blended

Cold press paper

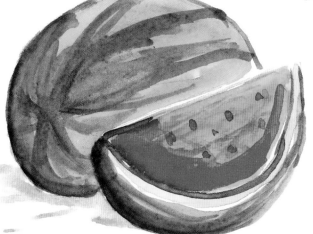

Left **Samantha Nielsen,**
Watermelon on Hot Press, 2018.
Each layer was quickly placed on
top of another with some dry time
in between. Hot press paper is a
great way to leave some 'hard'
edges instead of blending.

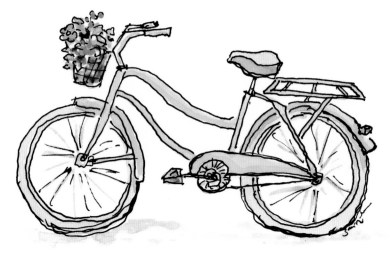

Right **Samantha Nielsen,**
***Yellow Bike*, 2017.**
Using a spray bottle to wet the
palette helps to create a painting
faster. The less time you spend
preparing materials, the more
time there will be to paint.

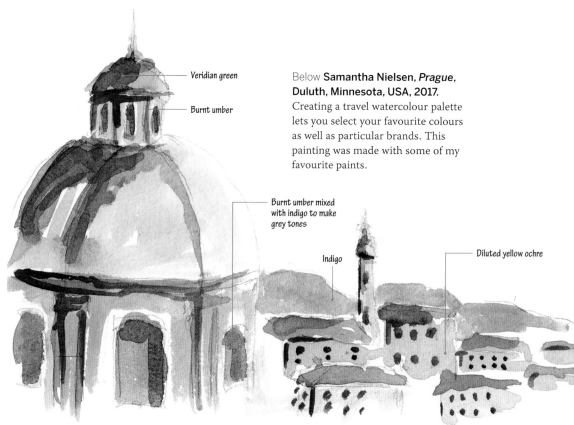

Veridian green

Burnt umber

Below **Samantha Nielsen, *Prague*,
Duluth, Minnesota, USA, 2017.**
Creating a travel watercolour palette
lets you select your favourite colours
as well as particular brands. This
painting was made with some of my
favourite paints.

Burnt umber mixed
with indigo to make
grey tones

Indigo

Diluted yellow ochre

Palettes for on the go

Being able to transport paint can be helpful when practising on-location painting. Having something that is small and compact makes it easy to paint at any time, anywhere, and there are several different ways to set up a travel palette.

5 ideas for palettes

Palettes The painting palette is the container that holds the paint. Pan paints often come in a set where the palette is part of the lid. If you buy paints in a tube, you can buy an empty palette and fill it with the watercolours of your choice.

Travel sets Being able to paint on the go is a great way of developing watercolour skills. In order to paint on location, it is helpful to have a travel set of watercolour paints.

Build a set Many artists are very particular about the supplies they use. Getting an empty travel set and filling it with paint from tubes, or buying individually wrapped paints that can also be placed in a metal tin, is a great way to individualise your travel palette.

Bring water Using a spray bottle to get your paint wet is a fast and easy way to prepare your whole palette. Most travel sets are quite small, so it only takes a few sprays and your paints are ready to use.

Water in a brush If there is not enough time to pack up a spray bottle and a few jars with water, find a brush that holds water in the handle. Water will seep through the bristles onto your palette, making the paint even more accessible.

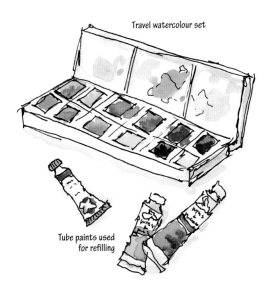

Travel watercolour set

Tube paints used for refilling

Left **Samantha Nielsen,**
Watercolour Set, 2018.
Watercolour travel sets such as this Winsor & Newton one are great for painting on the go. They come with the paint already in them, and they are easy to refill when the paint runs out.

Brushes

There are many things a single brush can do, and learning about brush styles as well as how to use the brush in different ways will help develop technique. Hand placement, brush style and the way a brushstroke is applied can all have an impact on how the paint reacts on paper.

5 thoughts on brushes

Variety of brushes Having a variety of brushes will help with achieving different techniques. Brushes such as a wash brush, round brush and fan brush are great for achieving different (and fast) results.

Vary angle and pressure One brush can create many different styles of strokes. Try holding the brush at a different angle to see what kind of mark-making results. Varying pressure will also have an impact on what the paint will do.

Hand placement In order to be loose with your marks, it may be helpful to hold the brush towards the back third of the handle. Having a larger range of motion will make creating expressive washes and lines easier. However, if you want more control over your mark-making, move your hand closer towards the bristles when creating tight detail.

Bristle impact Watercolour brushes come with different types of bristles. Some brushes are made with synthetic hair, while others are made with natural hair. Natural hair brushes will hold more water and will bounce back to their original shape more quickly, but synthetic hair brushes are still easy to use.

Start with a few Just like paints, having too many brushes can become overwhelming when trying to paint quickly. While a variety of brush styles is important, in order to paint quickly it is best not to waste time shuffling through brushes. Having one or two of each variety is plenty when starting out.

Right **Samantha Nielsen, *Brush Examples*.** Brushes make a big difference to the types of techniques you can achieve. Helpful ones to have are a fan brush, a few sizes of round brush, and one or two flat/wash brushes.

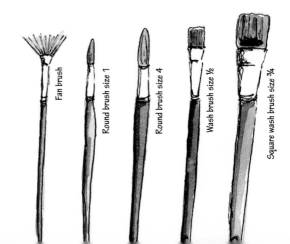

Fan brush · Round brush size 1 · Round brush size 4 · Wash brush size ½ · Square wash brush size ¾

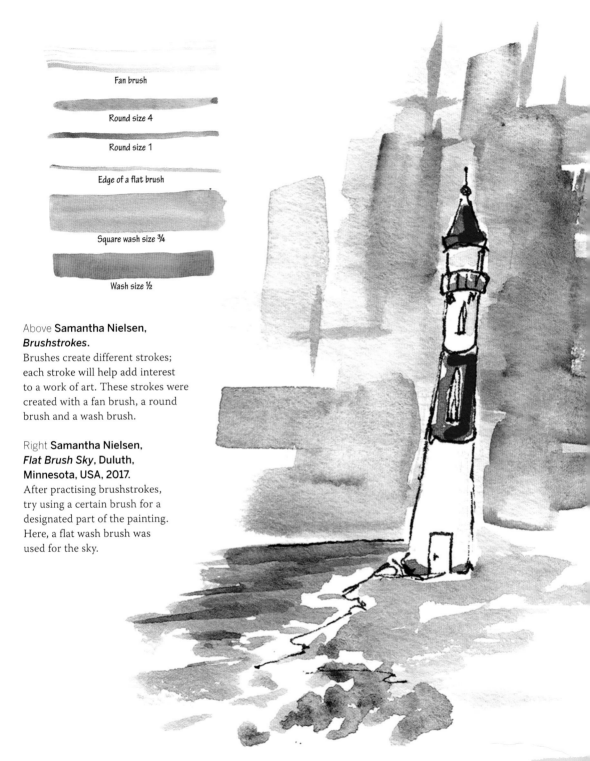

Fan brush

Round size 4

Round size 1

Edge of a flat brush

Square wash size ¾

Wash size ½

Above **Samantha Nielsen,**
Brushstrokes.
Brushes create different strokes;
each stroke will help add interest
to a work of art. These strokes were
created with a fan brush, a round
brush and a wash brush.

Right **Samantha Nielsen,**
***Flat Brush Sky*, Duluth,**
Minnesota, USA, 2017.
After practising brushstrokes,
try using a certain brush for a
designated part of the painting.
Here, a flat wash brush was
used for the sky.

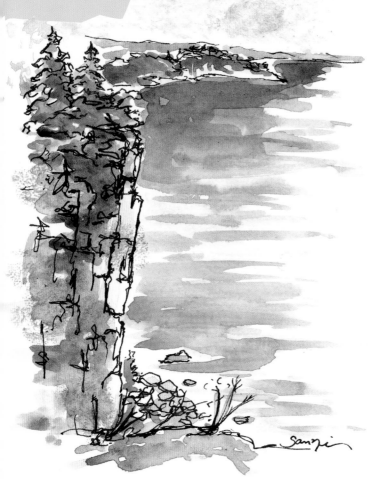

Below **Samantha Nielsen,**
***Sponge and Greens*, 2017.**
A sponge is a great way to add
a quick background, as well as
texture to a painting. Adding
texture can make a painting feel
finished in a short amount of time.

Above **Samantha Nielsen,**
***Palisade Head*, Duluth,**
Minnesota, USA, 2017.
In this painting, a quick wash
was painted first, and then
a sponge was used to create
texture in the rocks.

Right **Samantha Nielsen,**
Poppies, 2017.
Here, I used masking fluid to block
off the poppies before creating the
background. This allowed me to
paint the background quickly.

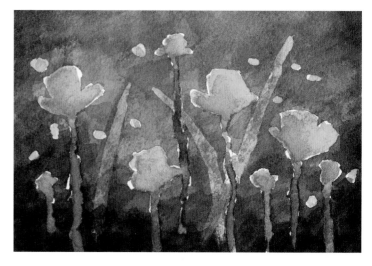

Supplies: the extras

There are many supplies that are not essential in order for you to become a successful watercolour artist, but some will take a watercolour painting to the next level. While most of these supplies can be used quickly, the set-up process will add a couple of minutes to a painting.

5 tips for extra supplies

Useful tools to have Some tools are not always necessary, but will make a difference in tackling watercolour techniques. Start acquiring items such as masking fluid, tape and a sponge in order to perfect some of the watercolour techniques in this book.

Tape the edges If you want to paint on loose watercolour paper, taping down the edges will create a clean border that acts as a frame for the picture. This helps keep the focus on the colours used.

Masking the white Masking fluid will help block off sections that you want to remain white. This tool will also help when creating watercolour backgrounds, and will allow for the backgrounds to have energy and movement.

Sponge with speed A fast and easy way to add texture to a painting is with a sponge. Try using a sponge to create a background to a painting or texture to rocks. Having a variety of textures in a painting will also add interest for the viewer.

One at a time These materials will be further explained over the course of this book, but keep in mind that it might be best to try one of these tools out at a time in order to find out what works for you.

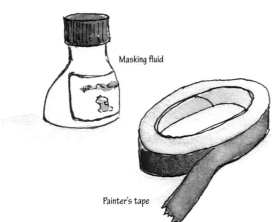

Masking fluid

Painter's tape

Left **Samantha Nielsen,** *Tape and Masking Fluid*, 2017.
Supplies such as tape and masking fluid are beneficial for certain watercolour techniques. Using these supplies in advance will help cut down on time when you're ready to paint.

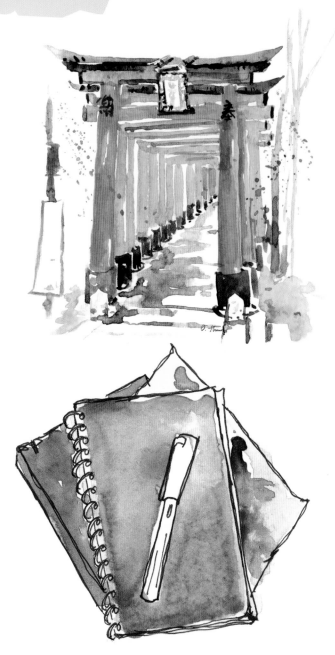

Left **Amara Strand, *Fushimi Inari-taisha*, Kyoto, Japan, 2017.**
Try using a larger sketchbook to allow space for larger brushstrokes and imagery that is more dynamic and bold.

Below **Nel Correa, *Personas de Metro*, Medellín, Colombia, 2017.**
Creating a sketch or painting on toned paper can change the whole feel of a piece. Try using the tone of the paper as a value or background.

Above **Samantha Nielsen, *Sketchbooks*, 2017.**
Spiral bound and hard bound sketchbooks are both useful for different reasons, and testing out a variety will help you find a favourite.

Sketchbooks for watercolour

Practising in a sketchbook is a great way of developing technical skills, as well as giving you the opportunity to play! It should be a space where the pressure is off and the experimenting begins. There are many different traits that a sketchbook can have, and discovering what works best for you can take time. A sketchbook can be helpful in building your artistic voice.

5 considerations for sketchbooks

Toned paper Not all sketchbooks are filled with white paper. Try a sketchbook with toned paper to see what effect it has on the watercolour. Using the tone of the paper as a value within a painting is an easy way to liven the overall piece.

The right size Sketchbooks do not have to be small. In order to practise loose, sweeping motions and larger brushstrokes, it is helpful to have more space on which to work. Choosing an appropriately sized sketchbook will allow room for you to create larger paintings quickly.

Binding Using a sketchbook that's spiral bound rather than hard bound is not going to change the quality of your painting and is strictly a personal preference. Removing paintings from a spiral bound sketchbook is much easier, while a hard bound will stay intact if you like to use it as a travel sketchbook.

Make mistakes One common error that people make with a new sketchbook is never using it! A brand new book can be intimidating to some beginner artists because they do not want to make a mistake in their clean sketchbook. But the point of a sketchbook is to practise. Do not expect to create a perfect masterpiece; making mistakes will help with growth.

Brands Having multiple brands of art supplies is not a bad thing. While many artists have a favourite, there are a wide variety of options that offer differring results. Try out different sketchbooks to learn how each kind of paper will handle water and pigment.

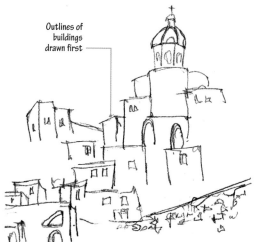

Outlines of buildings drawn first

Left Samantha Nielsen, *Pencil Sketch 2,* **Duluth, Minnesota, USA, 2017.**
This sketch started from basic shapes. Outlines of the buildings were created, before windows were mapped out. The windows were drawn loosely.

Below Samantha Nielsen, *Colourful City,* **Duluth, Minnesota, USA, 2017.**
There is more detail that could have been added to this painting, but it also gives enough information for the viewer to understand the scene.

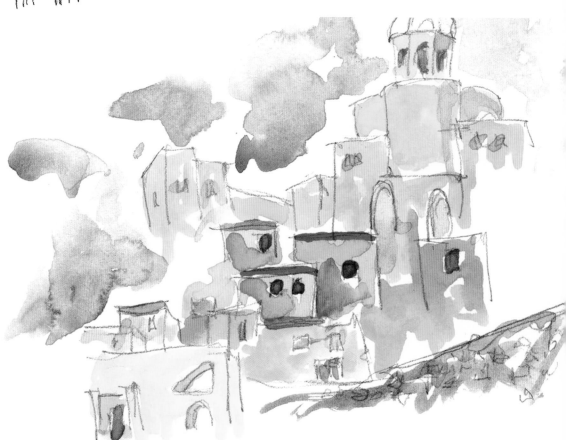

Fast planning with pencil

Not all paintings have to start right away with paint. It is fine to plan where a painting will go before pigment is added to the paper. Take time to visualise the finished product and overall composition. Sometimes using pencil will not be necessary, but even quick paintings can benefit from some kind of plan.

5 ways to plan with pencil

Start with a sketch Sometimes it can be difficult to plan out a painting without having a 'road map'. Before you begin painting, it can be helpful to create a loose sketch with pencil. The security of having an eraser can help as you learn how to make artistic decisions.

Find your horizon For landscapes and cityscapes, finding where the horizon line will be on the paper is the first step. The horizon line sets the stage for the rest of the imagery. Experiment with having a high or a low horizon line to see how this can affect the composition.

Create an outline Regardless of what imagery is being painted, starting with a loose outline will improve the end result. Whether you are painting a city, an animal or an abstract piece, pencil outlines are a good way to set yourself up for success.

Do not get lost in detail A pencil sketch can also help with speed – as long as time is not wasted on details. A sketch can effectively set up the scene, but save the detail for when paint is applied.

Avoid heavy drawing Water added on top of pencil marks can create a muddy wash of graphite if there is too much pencil on the paper. To keep the pencil marks from mixing with the water and pigment, draw lightly with very little pressure.

Mixing colour quickly

Colour is one of the most important things to learn about, since it is the biggest part of creating a painting. When starting out, it may be helpful to focus on using just a few colours at a time so that the process of colour selection does not become overwhelming.

5 methods for mixing colour

Work with primary colours All colours can be created from red, blue and yellow. There are ways to get different hues of certain colours, but many can be created from just these three pigments. In order to mix colours quickly, it may help to have a limited colour selection so time is not wasted on decision-making.

Wet paint with ease Instead of dipping a brush in water to wet pigment, rinse and repeat, a fast way to add water to watercolour paint is with a spray bottle. Spray the paints before beginning and the colours will be ready for use right away.

Mixing on the paper Letting colours interact on the paper is another way of mixing colours together. When two wet edges of a watercolour painting meet, the colours will bleed together, creating interesting combinations. Experiment to discover where this technique will work best.

Try unmixed pigment Learning how to paint quickly takes time, and eliminating one step of the process can help with speed. You do not need to create every colour by mixing. Switch it up by choosing to colour straight from the tray to add variety to the painting. This is also a great way to have intense colour on certain areas.

Do not get caught up in perfection Not every colour will mix the way you expect, and paint can appear differently on a watercolour tray compared to watercolour paper. Colours will also dry slightly lighter than how they look when they're wet. Do not be afraid to try out new colours in order to see how they dry.

Red and blue create purple

Yellow and blue create green

Red and yellow create orange

Left Samantha Nielsen, *Colour Splashes*.
Sometimes colour does not need to be mixed beforehand and can interact on the paper. These colour splashes were quickly created by placing the pigment and letting it bleed together.

Below **Samantha Nielsen,** *Saxophone Man*, 2017.
Starting with a limited colour selection helped in choosing colour quickly for this piece. That way, more time could be spent on establishing the form of the saxophone player.

One colour can add texture when the paint is layered

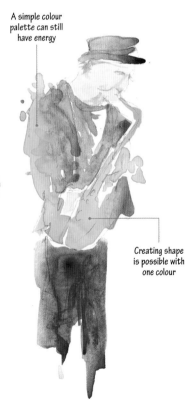

A simple colour palette can still have energy

Creating shape is possible with one colour

Let colours mix together on the paper to save time

Above **Samantha Nielsen,** *Colourful Bird*, 2017.
A great way to save time is by using paint straight from the tray. None of these colours were mixed, and the intense colour creates texture on top of the feathers.

Transporting and caring for your tools

Taking care of art tools ensures that your supplies will last for a long time. It is also important to transport tools safely so they do not get ruined moving from one location to the next. Though not all of the supplies mentioned are necessary for painting, they will definitely come in handy.

5 tips for transporting tools

Use a brush roll Transporting brushes in the proper way is important because it keeps your brush ends nice and usable. A roll that holds your brushes also keeps them organised so you can pick out the brushes with ease.

Keep tools together If travelling with watercolours is your aim, a great way to keep all the supplies together is by having a backpack for the materials. This way, when you want to rush out the door to capture a breathtaking landscape, the supplies are all ready to go.

Keep tools clean Brushes that are not cared for will only make painting more difficult. Watercolour paints are not an intense material, so a good rinse with water will take out most of the pigment. However, it is always a good idea to wash the bristles with brush soap occasionally to ensure they stay in great condition.

Advance preparation Taping watercolour paper to a sturdy board will help with facing the elements, such as wind, when painting outdoors. Do this before heading out on a painting session to cut down on the preparation time on location.

Bring what is needed Painting on location is about capturing the moment, so there is no need to transport a whole painting studio. Bring the essential supplies so the painting process can stay focused and you do not waste time trying to find the few supplies you actually need.

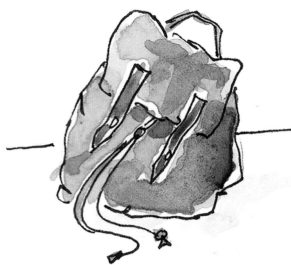

Below **Samantha Nielsen,**
Clean Brush, **2018.**
Supplies that are cared for
will last much longer. Take
the time to wash out brushes
and store them safely.

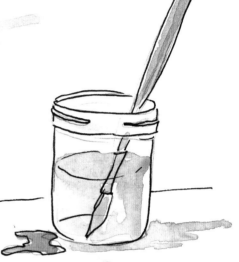

Above **Samantha Nielsen,**
Backpack, **2018.**
Bringing only the essential tools
in one bag will make the process
quicker; the less that has to be sorted,
the more time there is to paint.

Left **Samantha Nielsen,**
Drawing Board, **2018.**
Taping watercolour paper to a
drawing board keeps it in one
place and stops the wind from
blowing it away. It also gives
you a hard surface to paint on.

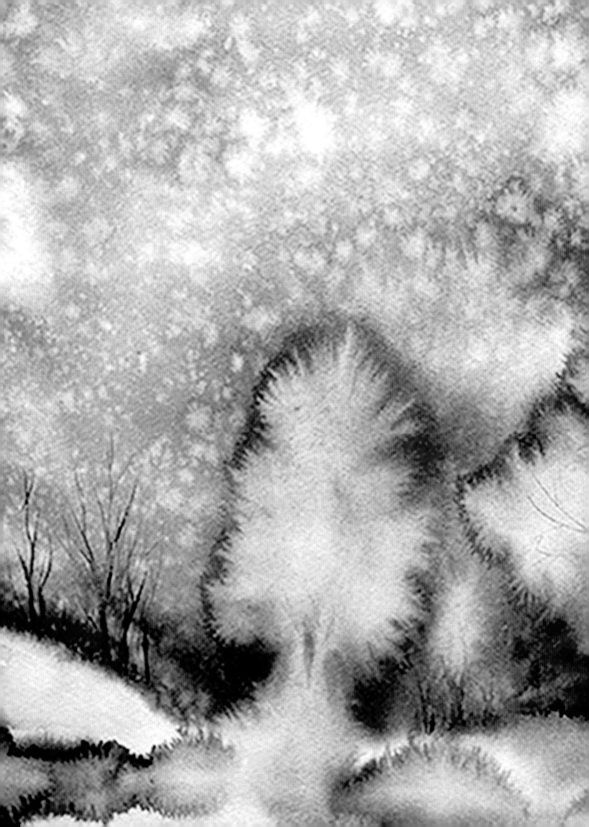

2

Easy techniques

Having the right tools is the first step, but you will not be able to use those tools properly until techniques are learned. Gaining control of tools, such as brush control and colour mixing, will help push the most basic techniques to the next level. Each watercolour skill and process can be adapted to a short time limit. This chapter will discuss some of the most common watercolour techniques, such as how to quickly create washes, splatter techniques and lifting paint, as well as layering and glazing.

Left **Anne-Laure Jacquart,** *Frosty Dreamlike Landscape*, **Douai, France, 2017.** One of the techniques explained in this chapter is the bloom technique. When used in the right way, the bloom technique can add energy to an already beautiful painting.

Right **Samantha Nielsen,**
Flat Wash & Graded Wash.
These two examples show
different kinds of washes.
First is a flat wash on dry
paper, followed by a graded
wash on dry paper.

Create a
flat wash by
applying the
wash as evenly
as possible

A graded wash
graduates from
dark to light
without adding
more paint

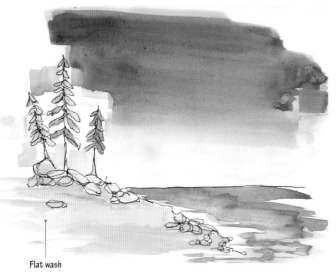

Left **Samantha Nielsen,** *Three*
Pines – First Stage, Duluth,
Minnesota, USA, 2017.
Here, a graded wash was utilised in
the sky. Notice how the edges are
not perfectly complete, and the sky
was painted in a sweeping motion,
adding energy. A flat wash was
used on the rocks and trees.

Flat wash

Graded wash

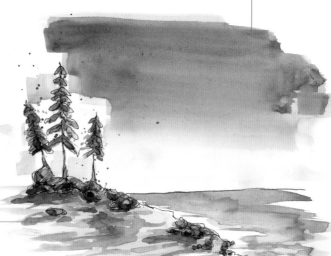

Right **Samantha Nielsen,** *Three*
Pines – Second Stage, Duluth,
Minnesota, USA, 2017.
The flat washes helped to establish
which colour went where. Layers
were added – allowing each to
dry – and the intensity of colour
increased to create a finished
sketch and painting.

Layers of
colour added

Washes

One of the most basic and commonly used watercolour techniques is a wash. There are different ways to approach a wash, and knowing when to use certain techniques is a way to create paintings that pop. Washes allow for a lot of paper to be covered in a short amount of time.

5 wash methods

When to wash Knowing when to use a technique can help in creating great watercolour paintings. A common time to use a wash is when large areas of paper are being covered, such as for land, sky or water. A wash is another way to create the base coat or undercoat for any watercolour painting.

Flat wash Load the brush with paint (always mix more paint than needed) and start painting from one edge of the square to the next. If the paint seems to become less intense, add more paint to the brush. Absorb any excess puddles that have been created with a dry brush or kitchen paper – 'flat' can also mean 'even'. Create the wash as evenly as possible

Easy graded wash This process is similar to the flat wash, except instead of reloading the brush with paint more than once, soak up as much paint as possible from the beginning. Start at the top of the square, and sweep across once. Continue this motion to the bottom. More water can be added to the brush to even things out at the bottom, but gradation means the colour is changing from dark to light, so do not add more paint.

Work quickly and sweep Watercolour (and water) dries fast, so it is important to keep a steady pace. The direction you paint is also important. The brush should be making a sweeping motion from side to side, rather than top to bottom. This is especially important in the graded wash.

Room for experimenting After practising wash basics, try it again, but this time do not wet the paper first and see what happens. Notice how the edges or transitions seem 'harder' instead of blended – and that is fine! There is a time and a place for every technique.

Start with water: wet-on-wet

Adding water to paper before paint can have several different results and is a great way to let the paint work for itself. One of the biggest challenges with watercolour is learning how not to be in complete control, but that is essential in practising some of these techniques.

5 wet-on-wet techniques

Wetting the paper For this technique, painting a section of the paper with clean water is the first step. When the paper is wet, it is time to add paint; you will notice how the paint moves around the paper with ease.

Let the paint blend together Try wetting the paper and then adding two different colours of paint close together. Let the paint 'speak' for itself, and do not overwork it. Try loading the brush with pigment, setting the brush on the wet paper and seeing how the colours interact.

Avoid too much water The paper needs to be wet, otherwise this technique will not work, but if there is too much water it is going to dilute the paint and warp the paper too much. Watercolour paper naturally warps when it is wet, but using the right amount of water will let you retain some control. There should not be a puddle of water on the paper.

Speed matters Working quickly with wet-on-wet is crucial, especially when using high-quality paper. Because quality papers are made out of cotton, the water will be soaked up very quickly. Work quickly and add paint to the damp paper before it dries.

Be patient Let the paper dry completely before adding pigment to a new area of the painting. Watercolour paper can only handle so much water at a time. Let areas of the paper rest before more water and pigment are added.

Above **Samantha Nielsen,**
Wet-on-Wet Flat Wash.
This example is a flat wash,
but the colour is evenly
blended because the paper
was damp before painting.

Above **Samantha Nielsen,**
Wet-on-Wet Graded Wash.
The paper was also wet before
creating this graded wash. The
transition between light and dark
is much smoother when just the
right amount of water is added.

Above **Samantha Nielsen,**
Clouds, **2017.**
These clouds were created fast
enough that the water did not dry
before paint was added, but once
the paint was placed, the colours
were left to blend on their own.

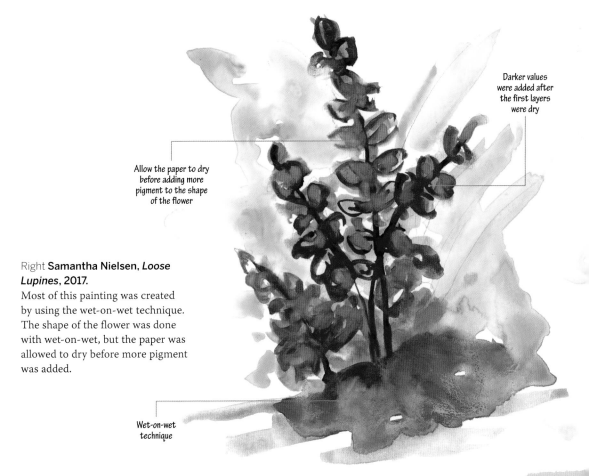

Darker values
were added after
the first layers
were dry

Allow the paper to dry
before adding more
pigment to the shape
of the flower

Right **Samantha Nielsen,** *Loose
Lupines,* **2017.**
Most of this painting was created
by using the wet-on-wet technique.
The shape of the flower was done
with wet-on-wet, but the paper was
allowed to dry before more pigment
was added.

Wet-on-wet
technique

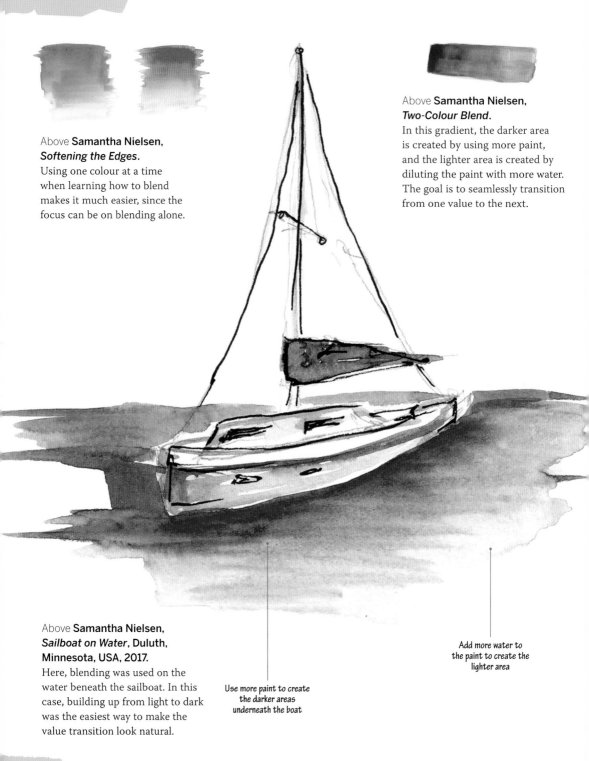

Above **Samantha Nielsen,**
Softening the Edges.
Using one colour at a time
when learning how to blend
makes it much easier, since the
focus can be on blending alone.

Above **Samantha Nielsen,**
Two-Colour Blend.
In this gradient, the darker area
is created by using more paint,
and the lighter area is created by
diluting the paint with more water.
The goal is to seamlessly transition
from one value to the next.

Above **Samantha Nielsen,**
Sailboat on Water, Duluth,
Minnesota, USA, 2017.
Here, blending was used on the
water beneath the sailboat. In this
case, building up from light to dark
was the easiest way to make the
value transition look natural.

Use more paint to create
the darker areas
underneath the boat

Add more water to
the paint to create the
lighter area

Blending made easy

Blending is a great way to make watercolour paintings look more natural, but is dependent on how the watercolour brush is used. This technique can really take paintings to the next level, and creating even, smooth transitions between colours will make even the quickest of paintings impressive.

5 ways to blend

Start with one colour Fill a brush with one colour and try to create a swatch of colour that gradually goes from dark to light, similar to the graded wash. Make it simpler by trying this technique with one colour at a time so it is easier to identify when the brush has too much water or not enough.

Create a gradient Pick two warm colours or two cool colours. Start with one and gradually blend to the other, creating a gradient. Focus on the transition from one colour to the next; the goal here is to not be able to identify where one colour ends and another begins.

Blend with your brush Often a brush will be full of either water, pigment or both. However, sometimes using the brush as a blending tool is very helpful. If the brush is relatively dry, pigment that's already on the paper can be soaked back up. This technique will prove handy if a colour gets too dark too quickly.

Work non-objectively Practise blending colours on their own before applying this technique to an object or scene. Perhaps try painting different shapes and making one side gradually darker than the other, working from light to dark by adding layers on top, as well as dark to light by pulling from colour.

Balance pigment and water Blending colour is going to be much easier if the right amount of water and paint is being used. It takes time and practice to understand the 'feel' and figure out this ratio. If the colour is not blending as anticipated, try using more or less water, and then more or less pigment.

Basic bloom

A bloom is created by wetting a section of paper, painting that same section, and then filling the brush with water and letting droplets fall on the painted paper. The water creates the 'edges' and a web-like effect. Successfully incorporating this technique into a painting will help the bloom look not like a mistake, but an intentional decision.

5 approaches to bloom

Find the balance In order for a bloom to work, the paper and paint need to be just wet enough. If too dry or too wet, the bloom effect will be less obvious and will just look like a light smudge on the paper.

Switch up the brush size Different-sized brushes will create different-sized blooms. The amount of water used to create a bloom impacts how far the bloom will spread out. Try creating blooms with both small and large brushes.

Use darker colours A bloom will show up on any colour when done correctly, but when learning this technique it may be easier to test it out on a darker colour in order to clearly see if the bloom is working correctly.

Merge colours with the bloom Using two or more colours and creating a bloom where the colours meet can be a great way to be loose with the paint. Just like the wet-on-wet technique, in this instance it is important to place the droplet of water and let the paint do the rest.

Use a light touch Moving the paint around with the brush once the bloom has been created will take away the edges the bloom naturally creates. Lightly touching the wet brush to the painted paper is all it takes to create a quality bloom.

Smudges occur if the paper is too wet or too dry

When the paper and paint are just wet enough, a web-like texture will occur

Above **Samantha Nielsen,** *Soft Bloom.*
This is what happens when water is added to the colour swatch too early or too late. There are light smudges, but the edges of the bloom are not defined.

Above **Samantha Nielsen,** *Strong Bloom.*
This bloom was created at just the right time. The water droplet was gently touched to the paper, and the edges of the bloom have a web-like texture.

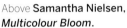

Above **Samantha Nielsen,** *Multicolour Bloom.*
For each of these splashes, two colours of paint were placed on the paper, and a bloom was created where the colours met. Choosing colours that mix well together – i.e. yellow and blue – will make the bloom even more exciting.

Right **Anne-Laure Jacquart,** *Frosty Dreamlike Landscape,* Douai, France, 2017.
Anne-Laure created almost this entire piece with different blooms, using differing brush sizes or different amounts of water droplets.

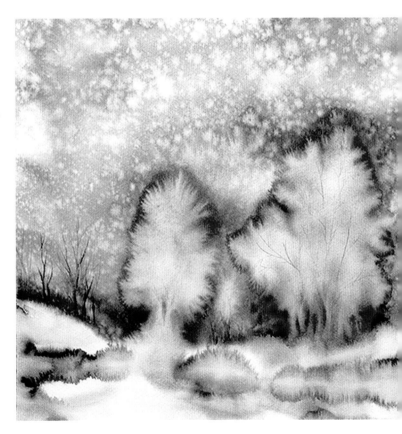

Pulling from colour

Because watercolour is a loose material, many feel as though it is not possible to have control. While it is important to let the paint move the way it wants to and speak for itself, knowing how to work the paint gives you all the control that is needed. Pulling from colour is a technique where paint is placed on the paper, and the artist controls where it goes from there.

5 ways to pull from colour

Use strong pigment Starting off with more paint than water on the brush will give more chance of success. Make a straight line of pigment on the watercolour paper. Next, add water to the brush and gradually pull colour from the line of paint on the page.

Create sharp edges Pulling colour can be used to create very sharp edges, such as on a building or on geometric shapes. Using a square wash brush also aids in keeping the edges crisp and even.

Easy shadows Since pulling from colour involves starting with a bold line of pigment, a shadow can be created right from the beginning. Just keep the line of pigment stronger than the colour that's being pulled away.

Achieve seamless gradation Pulling colour is not just for sharp edges; you can paint more organic shapes and still be pulling from colour. For example, placing an intense line of colour at the base of a fruit painting, and gradually pulling that colour across to the other edge, can help create a transition of value that looks even and smooth.

Creating form the easy way Something that can be difficult when learning to paint with watercolour is defining the shape and form of the objects being painted. Pulling from colour will help show the viewer a light source and an obvious edge to certain objects.

Right **Samantha Nielsen,**
House in Greece, Duluth,
Minnesota, USA, 2017.
The colour pulled on the yellow
and blue buckets not only creates
a shadow but also emphasises
form. The line of paint that the
bucket was started with makes
the edge clean and strong.

Pigment line

Using a wet brush,
pull the pigment
across the paper

Below **Samantha Nielsen,**
Bananas, 2017.
Pulling colour does not need to be
confined to geometric shapes; it
can also create a smooth gradation
on more organic shapes.

Above **Samantha Nielsen,**
Colour Example.
Both colour swatches started with a
strong line of pigment. A wet brush
was placed near this line and used to
pull the pigment across the page.

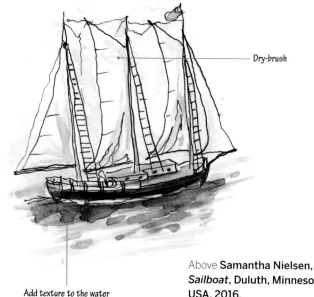

Dry-brush

Above **Samantha Nielsen,**
Brushstrokes.
Try using all sides of the brush
(wide and narrow) and moving
the brush in different directions.
This example shows more obvious
texture, as well as subtle texture.

Add texture to the water

Above **Samantha Nielsen,**
Sailboat, **Duluth, Minnesota,**
USA, 2016.
Texture and dry-brushing can
be layered on top of other
colour and washes. Here,
dry-brushing was used on the
water as well as the sails.

Plenty of pigment and
water used

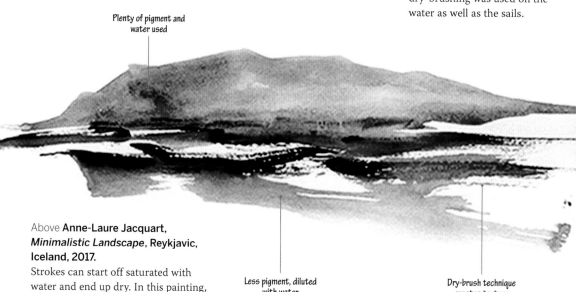

Above **Anne-Laure Jacquart,**
Minimalistic Landscape, **Reykjavic,**
Iceland, 2017.
Strokes can start off saturated with
water and end up dry. In this painting,
the edges of the water and parts of the
land were completed with dry-brush.

Less pigment, diluted
with water

Dry-brush technique
creates texture

Dry-brush

One of the most controllable techniques is dry-brushing. Because
there is hardly any water used, the pigment stays on the brush and appears
where the brush is placed. You can either start using dry-brush right from the
get-go, or dry-brush will naturally happen if a stroke continues to be
pulled across the page until the water has run out.

5 dry-brush techniques

Limit the water In order to achieve the dry-brush technique, the bristles must be relatively dry. The small amount of water should get the paint wet enough to stick to the brush. You should also feel that you have control over the paint with dry-brush.

Texture made easy The dry-brush technique is a great way to create texture within paintings. Find areas of the painting that seem to thrive off of texture, such as grass, water, tree bark or feathers.

Layer on top Dry-brushing does not have to be used on its own. You can dry-brush over a wash with no trouble. Try using a dry-brush technique on water to create ripples. Paint a flat wash of blue, let it dry, then go over certain areas with dry-brushing to add ripples.

End an edge Using dry-brush on the edges of a brushstroke is an effective way to 'finish' a painting. Try using this technique when painting water or land. It can create a nice transition between paint and the white of the paper instead of ending with a hard edge.

Switch up the brush Any watercolour brush can create texture, but it can be fun to experiment with different types of brushes, such as a fan brush. Since the bristles are already far apart, it makes the dry-brushing technique very easy.

Simple splatter

A technique that can be full of energy is one that can also get out of hand. Learning how to use splatter effectively in a painting will take artwork from an amateur level to experienced in no time. Knowing when to use this technique is the key to creating a quick piece that still looks professional.

5 uses for splatter

Use splatter as an accent Since painting quickly is the goal, splatter can help with adding energy to an already quick watercolour painting. You can use splatter as an accent to the painting that has already been created.

Control the splatter Be selective about where the splatter should end up. An easy way to do this is to use pieces of scrap paper to cover any areas that should not have splatter.

Use colours found in the painting Finding a colour that is already used in the painting will help the splatter fit in with the rest of the work. Splatter should be used to enhance the painting, not detract from the imagery.

How to splatter quickly There are two ways that work best for splatter. Loading the brush up with paint and hitting the handle of the brush against an extended finger works great. You can also pull the bristles back and slowly let them go to spray the page with paint. Keep the brush close to the paper for both techniques.

Leave it out! In order to avoid overusing this technique, treat splatter as a special surprise. This technique can get out of hand quickly, so when in doubt, take a break from the splatter and look at the painting with fresh eyes the next day before deciding what to do next.

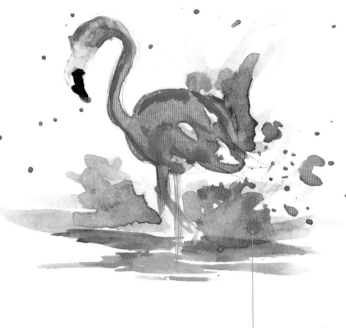

Left **Samantha Nielsen, *Flamingo*, 2017.**
Here, the splatter was created with pink to further accent the bright colour of the flamingo. The painting was not fully dry when splatter was added; notice how the pink bleeds into the green.

Below **Samantha Nielsen, *Coffee Cup*, 2017.**
This splatter was created by loading the brush up with paint and gently tapping the handle of the brush. Having enough water on the bristles will help the paint drops fall to the page with ease.

Splatter merging with underlying wet colour

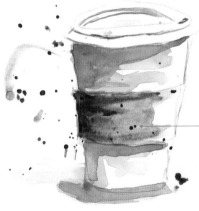

Splatter added to dry painting by tapping the handle of a loaded brush

Below **Samantha Nielsen, *European Tour*, Prague, Czech Republic, 2016.**
It is important to be intentional about where the splatter ends up. Here, the splatter is minimal, but is just enough to bring life to this quick piece.

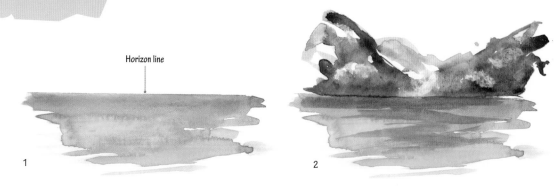

Horizon line

1

2

Above **Samantha Nielsen,**
Horizon Line 1.
This horizon line was created using
tape, which is why it looks so even
and straight. The paint was given
time to dry before the tape was
peeled off the paper.

Above right **Samantha Nielsen,**
Horizon Line 2.
After the tape was used, mountains
were then added where the ground
horizon and base of the mountain
met. The horizon line can be left
crisp, or you can blend it.

Right **Samantha Nielsen,**
Colour Splash.
Blocking colour can create
interesting patterns on an abstract
painting. Here, tape was laid on the
paper in different directions. After
the paint dried, the tape was moved
to a new position.

Tape

A great tool to use when creating fast watercolour paintings
is tape. It can be used to help with techniques within a painting, or it can
be used to make a finished painting look framed and complete. Making sure
the right tape is being used is important for these techniques to work.

5 ways to use tape

Crisp horizon line One of the most common reasons to use tape in a watercolour painting is to create a crisp horizon line. Decide where the horizon line will go, and lay a strip of tape down to protect the land or water from bleeding into the sky.

Creating a border To achieve an effective border around a watercolour painting that is created on loose paper, applying tape around the edges is the way to go. Make sure the tape is even on all edges so the painting is nicely framed by the border.

Blocking paint easily Another easy way to use paint is in an abstract watercolour painting. Tape can block certain colours from bleeding into each other. The white paper that was protected by the tape can also form unique shapes and angles.

Protecting the paper There are specific types of tape that work best on paper; most are called 'artist's tape'. This tape will often be blue or green, and will not tear up parts of the paper when it is time to take it off.

Peel slowly Even though these techniques are all about achieving speed, if there is anything that should be done slowly, it is taking tape off a painting. If the tape is ripped off quickly, you risk tearing the paper, regardless of the kind of tape being used.

Masking fluid

Using masking fluid is a great way of easily blocking off certain sections of a painting while larger sections are painted. Once masking fluid has been placed on a page, the painting portion is quick and easy. The longest part of this technique is simply waiting for the masking fluid to dry.

5 masking fluid methods

Break it down The process of using masking fluid is quick, but the dry time cannot be avoided. In order to keep painting sessions short and fast, break down the painting into different sections. Place the masking fluid in one session, and the watercolour during the next.

Do not leave it too long The quicker the masking fluid can come off, the better. Masking fluid will not harm paper if it sits for a few hours, but avoid leaving it on the paper for days at a time. It can be hard to remove if it is left for too long and can tear the paper as it is being peeled.

Rapidly enhance the background Use masking fluid to cover the subject of a painting – that way the background can be painted quickly while using bright colours. The masking fluid will protect the main subject, and you do not have to worry about the background bleeding into the subject matter.

Detail with ease Since the background can be painted in a short amount of time when using masking fluid, more time can be spent on the main focus of the painting. Use the time saved on the background to concentrate on the details and colour selection instead.

Quickly remove by rolling To remove the masking fluid, start by rubbing a finger or an eraser along the edge. Once some of the masking fluid has started to peel back, continue the rolling motion, instead of peeling off the fluid in one big piece. This will prevent the paper from tearing up with the masking fluid.

Left and right **Samantha Nielsen, *Ballerina 1* and *Orchid 1*, 2017.** A quick pencil sketch was drawn to work out where the masking fluid needed to go. While the masking fluid dried, other tasks were completed, so the wait time felt minimal.

1

1

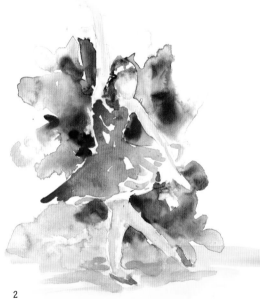

2

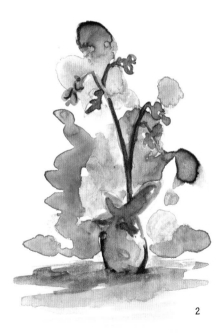

2

Above **Samantha Nielsen, *Ballerina 2*, 2017.** Everything but the ballerina was painted before masking fluid was removed. The background was enhanced because bold colours could be used without worrying about colour bleeding into the ballerina.

Above **Samantha Nielsen, *Orchid 2*, 2017.** After the background had been painted and allowed a short time to dry, the masking fluid was quickly removed by rolling an eraser along the fluid.

Fast ways to lift paint

Lifting paint can be used to improve a painting or remove a mistake. There are several different ways to lift paint, and some techniques will be more useful than others depending on the subject matter being painted and the intention behind the lifting. If better quality paper is used, lifting will be much easier and more effective.

5 ways to lift paint

Understanding lifting The process of lifting is just it sounds; lifting paint back off the paper. It can be used in any situation, but it is a great way to add highlights or create clouds.

Lift when the paint is wet While it is possible to lift paint back off the page when the paper and paint are dry, lifting is always easier when the paint is still slightly damp. On quality papers, if the lifting is done at the correct time, a section of painted paper can become nearly white again.

Precise (and quick) lifting Try using a paintbrush to lift paint off the page exactly where intended. Make sure the brush is clean and dry. Pull the brush over the paper and paint, wipe it off with a paper towel, and repeat until the paint has lifted away.

Easy lifting A paper towel is another way to lift paint and works especially well for creating clouds. The paint has to be a little wetter than when lifting with a paintbrush. Soak up any areas that should remain a lighter colour, and use varying pressure to control how much paint is soaked back up.

Create new textures Even though lifting is often used for something specific, such as creating clouds or highlights, try using this technique to create interesting textures. The more crumpled up the paper towel is, the more variation between lights and darks occurs, thus forming interesting textures.

Right **Samantha Nielsen, *Brush Lifting*.**
For this colour swatch, precise but quick lifting is demonstrated with the use of a brush. It is important to lift at the right time; if the paper is too wet, the paint will bleed back together; if it is too dry, the paper might remain stained.

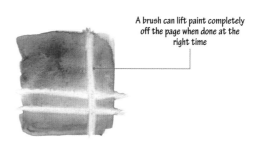

A brush can lift paint completely off the page when done at the right time

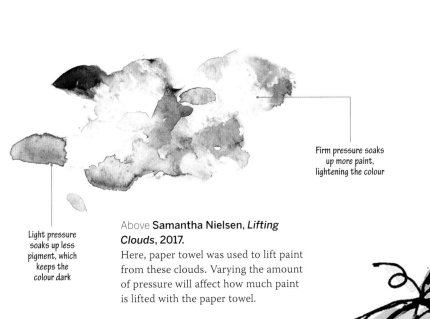

Above **Samantha Nielsen, *Lifting Clouds*, 2017.**
Here, paper towel was used to lift paint from these clouds. Varying the amount of pressure will affect how much paint is lifted with the paper towel.

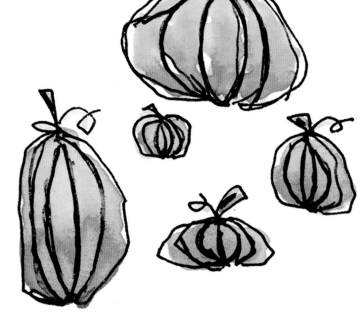

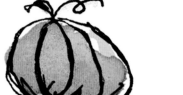

Above **Samantha Nielsen, *Pumpkin Assortment*, 2017.**
These pumpkins were originally darker, but if lifting is done when the paint and paper are just wet enough, colour can be lightened and removed to create a nice gradation or highlight.

1

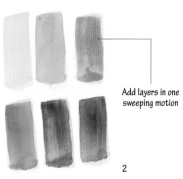

Add layers in one sweeping motion

2

Right **Samantha Nielsen, *Layer 1*.**
These swatches were created to
see what happens when new colour
is added on top. Pick one colour
at a time for the base swatch
to understand how the colour
is changing.

Above **Samantha Nielsen, *Layer 2*.**
By layering different colours on top
of one base colour, it is obvious how
the yellow underneath impacts the
top coat. Remember to add the layers
in one sweeping motion.

Base layer

Second layer
Third layer

Above **Samantha Nielsen,
Layered Leaves, 2017.**
Easy glazing can be done to add darker
values to a painting. In the flowers and
leaves, the darker value was created
by using the same colour, but layering
it on top to create darker shadows.

Right **Samantha Nielsen,
Layering Rectangles.**
Overlapping new colours can be
a fun way to discover how the paint
interacts on the paper. To prevent
bleeding, wait for layers to dry in
between coats.

Layering and glazing

Layering and glazing can be great fun, as well as adding so much depth to a painting when done correctly. Discovering how colours interact when they are overlapped, and learning how to layer to create shadows, will make a watercolour painting more vibrant! Layering and glazing will be successful when they are not overworked – or over-brushed.

5 layering and glazing techniques

Overlap new colours Experiment with overlapping different colours. Create a few swatches with the same colour, and see what happens when a new colour is layered on top. This is also a way to create new colours without mixing on the palette.

Leave to dry In order for layering to work, it is important that paint is placed on the paper and then left alone to dry. If the brush repeatedly goes over the same spot on the page before the paint has dried, the brush just soaks the pigment back up.

Glazing for value Layering paint is also called glazing. Glazing with one colour can create shadows. Select one colour and paint a strip on the paper. Continue adding one layer at a time to this same strip, allowing each layer to dry in between. Use this technique to create darker values.

Simple shadows and highlights Choosing a colour for the first layer can impact how the rest of the painting will proceed. Typically, warm colours are used for highlights and cool colours for shadows. Keep this in mind when selecting a colour for the first layer.

Listen to the paper Because watercolour paper comes in different weights, pay attention to when one area of paper has reached its limit. If the paper starts to degrade, then the limit has been reached. Try pushing it too far just to understand how much the paper can handle.

Below **Samantha Nielsen,** *Koi Fish,* **2016.**
Here, the water shows scumbling that is
close together. Instead of pulling the brush
in a long stroke, the brush was used to dab
colour on the page. Since each layer dried
underneath, the water shows at least three
layers of colour as the intensity increases.

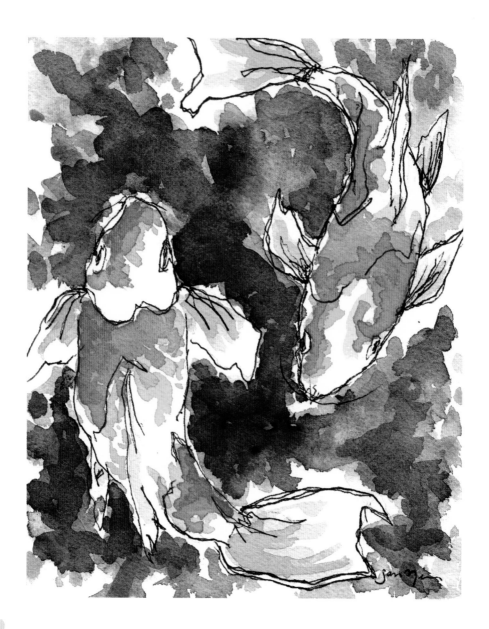

Basic scumbling

Scumbling is a technique that produces a kind of broken texture. It is often used for painting feathers, fur, texture on trees or in the land, as well as creating ripples in water. Short and long brushstrokes can be used to create basic scumbling, as long as the strokes are broken and not connected.

5 tips for basic scumbling

Lift the brush Scumbling is creating broken colour over another colour. In a sense, it is layering the paint, but in a loose and scratchy way. Practise by lifting the paintbrush every few seconds to break up the brushstrokes.

Wet over dry In order to achieve the scumbling technique, the first layer of paint needs to dry completely before scumbling is attempted. Just as with layering, let each brushstroke dry before adding more paint on top.

Long and short brushstrokes Scumbling does not have to be short brushstrokes (although it can be). Experiment with long and short brushstrokes to see what works best for different imagery. Furry textures on animals might work well with short brushstrokes, while blades of grass or ripples in the water might look nicer with long strokes.

Scumble close together Although scumbling is a 'broken' brushstroke, that does not mean the strokes cannot be close together. Perhaps instead of using long strokes for water, test out a round brush and apply the paint with a dabbing affect. As long as the paint is not being blended together, it is still a form of scumbling.

Softer texture Scumbling creates a different kind of texture than dry-brushing does. The edges are not as harsh and spotty, but the brokenness of the scumbling and the colour underneath still creates a sense of depth and texture.

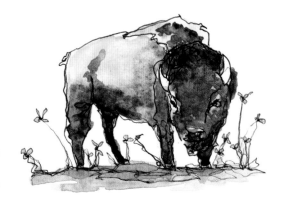

Right **Samantha Nielsen, *Bison*, Fargo, North Dakota, USA, 2015.**
Scumbling was used to create the texture in the bison's fur. Where the light colour meets the dark is where the brushstrokes started to break.

Paper and gravity

Tilting a painting is probably the easiest technique to do. What takes
a bit more skill is learning when and where to tilt the painting so the running
paint will add to the overall composition. Before beginning, make sure
the painting is wet enough, and then let gravity do the work!

5 ways of using gravity

Hurry before it dries Tilting a painting will move
the pigment, but this only works if the pigment is
still wet. Try tilting a painting almost immediately
after application in order to move the paint along
the paper.

Energise a composition quickly An easy way to
spice up a composition is to make some of the
paint run. Use gravity to help make paintings more
organic and free. Five-minute painting is all about
capturing the energy of the imagery in a short
amount of time; using gravity is a simple way to
add that energy.

Create a bloom As discussed on page 36, blooms
can be created by adding droplets of water on top
of paint; but a bloom can also be created by tilting
the paper and letting the paint run. When the
painting is tilted, the paint will naturally settle
towards the bottom.

Directional force Letting paint run towards the
bottom of a painting can also 'ground' the scenery.
There is a certain directional force that can be felt
from colour and pigment running towards the
bottom of a painting or towards the ground.

Tilt in different directions Paint does not have
to look like it is only running towards the ground.
Try tilting the paper in multiple directions as the
paint dries in order to see how different colours
blend together.

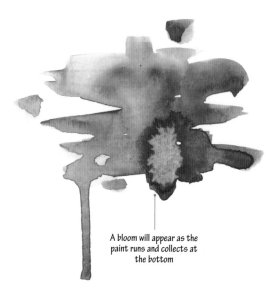

Right **Samantha Nielsen, *Blue Swatch*.**
This blue swatch demonstrates a bloom being
created by tilting the paper and letting the
paint run to the bottom. Where the paint has
run is where the bloom appears.

A bloom will appear as the
paint runs and collects at
the bottom

Right **Samantha Nielsen,**
Three Roses, **2017.**
The running droplets on the
bottom flowers give this
composition more energy and
excitement. If you add more
saturated areas of colour before
tilting the paper, the paint will
run smoothly.

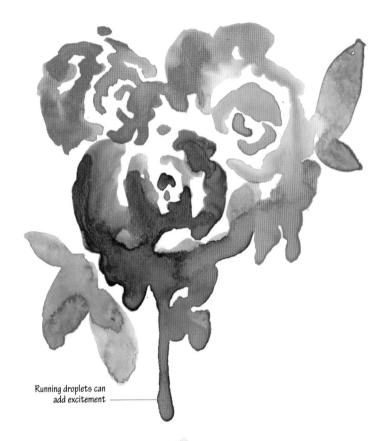

Running droplets can
add excitement ————

Bloom for
added texture

Tilting the paper
to make the
paint run

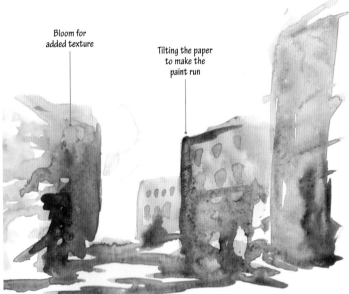

Left **Samantha Nielsen,**
Abstract Architecture,
Duluth, Minnesota, USA, 2017.
By letting the paint run down on
these buildings, darker pigment
collected towards the bottom,
thus grounding the buildings.

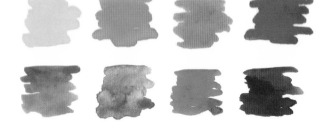

Below **Anne-Laure Jacquart,** *Woman in Red in an Old French Village,* **Locronan, France, 2017.**
Anne-Laure created this quick watercolour scene by grouping all the shapes in a single wash. The highlights in the windows are warm colours; the shadows behind the woman and on the rooftop are cool.

Above **Samantha Nielsen,**
Warm and Cool.
In order to know how to use warm and cool colours, it is important to know what they are. The top row comprises warm colours; the bottom row, cool.

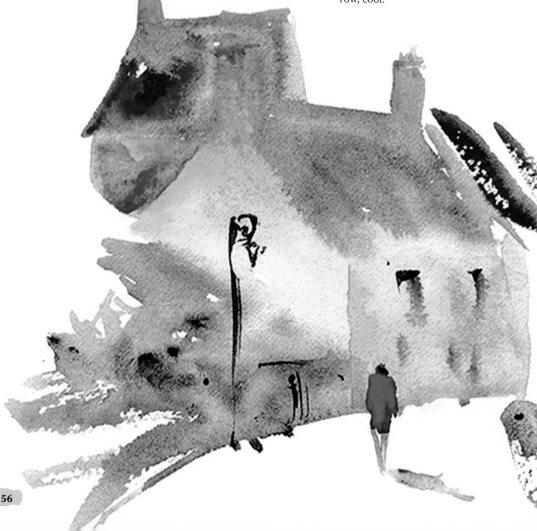

Warm and cool colours

Colour selection is important if you want to grow as an artist
and enhance your watercolour abilities. Learning to see all of the
different colours on one object and understanding the tones of shadows
and highlights will help liven up a painting. Understanding the best
way to use warm and cool colours is the first step of this process.

5 thoughts on warm and cool colours

Know the colours An easy way to remember
what the warm and cool colours are is to think of
temperature. Warm colours would make you feel
warm, such as the colours in the sun. Cool colours
would do the opposite.

Shadows and highlights One way to make
paintings more vibrant is knowing how to create
shadows and highlights. Often cool colours will
be used in shadows, and warm colours in
highlights. Practise painting different scenes
with this idea in mind.

Learning to see Part of understanding how to
use colour well is understanding how to see. For
example, if a piece of fruit is being painted, the fruit
will look much more interesting if other colours are
used instead of just the obvious ones.

Change it up Sometimes, if time is limited, having
to think about colour can be overwhelming. Objects
do not have to be painted the exact way they
appear in real life. Change it up and make it exciting
– turn brown roofs into blue roofs, and yellow
fruit into purple.

Mixing warm and cool colours One way to create
a variety of warm and cool colours is by mixing
them together. For example, yellow is a warm
colour and green is a cool one. Mix them together
to make yellow-green, which is a 'warmer' version
of a cool colour. The possibilities are endless!

Left **Samantha Nielsen,** *Lemon*, **2017.**
Adding cool colours in the shadows is a great
way to make a painting pop. Here, a bit of purple
and green were added to create the shadow on
the ground as well as the back edge of the lemon.

Easy ways to gain brush control

The best way to gain brush control is through practice, but there are a few things that will help in gaining brush control quickly. Learning how to paint small as well as large scale, understanding the kind of strokes brushes create and varying pressure will all help improve brush control.

5 ways to gain brush control

Try a variety of brushes Different brushes create different strokes, so practising with a variety of brushes (see page 16) will help establish better control of all types. This will also help develop your intuition and knowledge to understand which brush works best for particular techniques.

Quick, tiny paintings Painting in a tiny space can be difficult with watercolour because the paint can feel hard to control. At the same time, accepting the challenge of painting small will assist you with painting tiny details – and small paintings do not take long at all!

Large strokes Mastering the skill of painting on a large scale is just as important as learning how to paint small. While small paintings teach control of detail, large paintings will help with loosening up and developing brush control while still using a lot of motion.

Easy lines and patterns Instead of painting something specific, try a non-representational painting to see what kinds of lines and patterns can be created with the brushes you have. This will also help with learning how to paint in different directions, creating different line types, such as curvy and straight, as well as leaving space in between lines so the colour does not bleed.

Change the pressure Discover what kinds of brushstrokes can be created by varying the pressure applied to the paper. See what happens when more pressure is added, and when pressure is released. Practise this technique in a straight line as well as a curvy line.

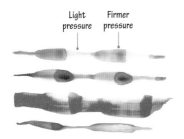

Light pressure Firmer pressure

Above **Samantha Nielsen**, *Brush Pressure*.
Varying pressure while painting a straight
line will help with understanding all that a
single brush can do. Here, each line was
started with a light touch, then more
pressure was added.

Below **Samantha Nielsen**, *Five-Minute
Trees*, 2017.
These trees were painted small-scale so the
focus could be on brush control and detail.
Painting small will allow for detail to be
added while still letting you complete
a painting quickly.

Below **Samantha Nielsen**, *Line Practice*.
The goal of this painting was to create
lines and patterns that were close
together, but without letting the lines
touch so the paint did not bleed.

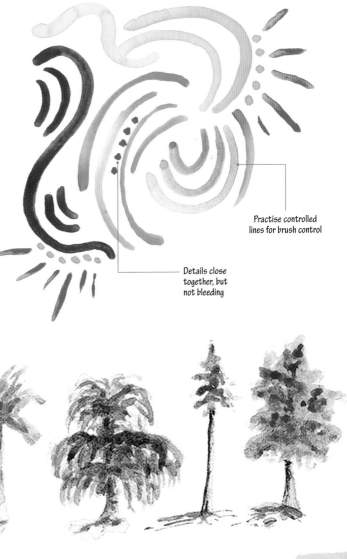

Practise controlled
lines for brush control

Details close
together, but
not bleeding

Ink line and watercolour wash

Adding ink line work into a watercolour painting is a terrific way to make the whole sketch feel full of life. There are multiple ways to approach this technique, some of which involve adding ink first, others watercolour first. Finding the balance between ink and watercolour is important, so the ink does not take over the whole painting.

5 techniques for ink line

Waterproof ink is best Before adding ink to any painting, make sure the ink is waterproof. If the painting is damp, or watercolour is added after sketching, the ink will bleed everywhere. Several pens are available with waterproof ink and will help with creating beautiful sketches.

Watercolour first, ink later Try painting before ink is added. Start by breaking the scenery down into shapes, and place sections of colour to divide and establish the imagery. Then add ink line work to give the objects form and establish edges and detail.

Ink first, watercolour later Next, try to capture a quick sketch in ink before adding any paint. Paint within the ink sketch, but do not stay confined to every single line that was drawn. And do not forget that speed is still important; do not get caught up in the line work and forget about the painting!

Let the watercolour speak The watercolour and ink do not have to be perfect; in fact, a painting can look more alive and exciting if the washes and lines are created quickly. Try not to become caught up in perfectly matching every colour.

Handling the edges with ease Since ink adds all kinds of energy to a painting, do not feel that every part of the paper needs to be painted. Allow some space for the eye to rest and move back around the painting. Leave some spaces white and let the paper breathe.

Opposite **Samantha Nielsen, *Lift Bridge*, Duluth, Minnesota, USA, 2017.** The colours in this sketch are not matched exactly with the scene being painted, but by adding ink to the sketch, the essence of the scene was captured.

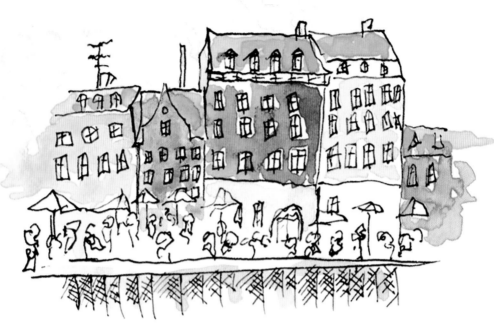

Above **Samantha Nielsen**, *Nyhavn*, Copenhagen, Denmark, 2016. When ink is used first, as in this sketch, sometimes working around different shapes with the watercolour is necessary. That being said, do not let the ink lines hold the paint back.

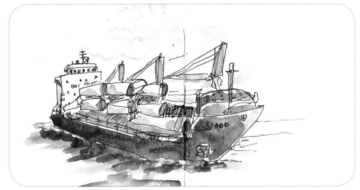

Above **Samantha Nielsen**, *Sjard*, Duluth, Minnesota, USA, 2017. Since ink adds more activity to a piece, allow the white of the paper to become part of the painting, letting the subject matter become the focus.

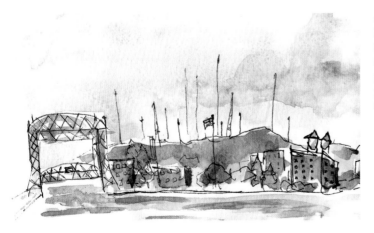

Light to dark

By painting from light to dark with watercolour paints, you can capture every detail of how light hits objects and scenery. Learning how to paint by gradually building up colour will also help you to develop brush control and gain a greater ability to focus on highlights and shadows.

5 ways to paint light to dark

Start with highlights Watercolour paints need to be layered to increase intensity and richness of colour gradually. Once a lot of paint is on the paper it becomes difficult to remove. For this reason, it is important to gradually build the colour if different values are needed.

Make a value chart Paint a chart that shows how intense colours can become with more layers. Start with one layer of paint and let it dry. Add another layer, leaving some of the first layer visible. Continue until five to six layers have been created or until the most intense and bold amount of colour is achieved.

Begin with a base Take the skills learned in the shading chart and apply those to an object. Most watercolour paintings start with a base coat to cover the paper, and over short periods of time additional layers can be added.

Listen to the paper If the watercolour brush starts to pick up parts of the paper, or a thin spot has begun while layering, too much water and pigment have been added. The better quality paper you use, the longer the paper will take to get to this point. Watercolour paper can only handle so much paint and water before its performance starts to suffer.

Easy colour swatches While learning the potential of certain colours, it may be helpful to keep a record of which colours have been used to paint a certain piece. For each colour and variation, paint a small square on a different sheet of paper that you can return to for future reference.

Deep scarlet Pyrrol red Mayan orange Neutral tint

Left **Samantha Nielsen,** *Colour Swatches.*
Colour swatches are helpful to remember which colours have been used, especially when paints are new. Remember to still pay attention to which colours are lightest and darkest.

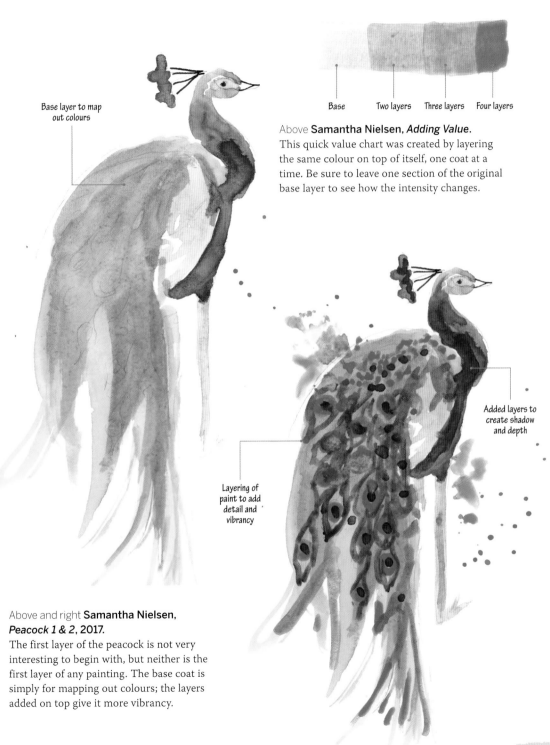

Base layer to map
out colours

Base Two layers Three layers Four layers

Above **Samantha Nielsen, *Adding Value*.**
This quick value chart was created by layering
the same colour on top of itself, one coat at a
time. Be sure to leave one section of the original
base layer to see how the intensity changes.

Added layers to
create shadow
and depth

Layering of
paint to add
detail and
vibrancy

Above and right **Samantha Nielsen,**
***Peacock 1 & 2**, 2017.*
The first layer of the peacock is not very
interesting to begin with, but neither is the
first layer of any painting. The base coat is
simply for mapping out colours; the layers
added on top give it more vibrancy.

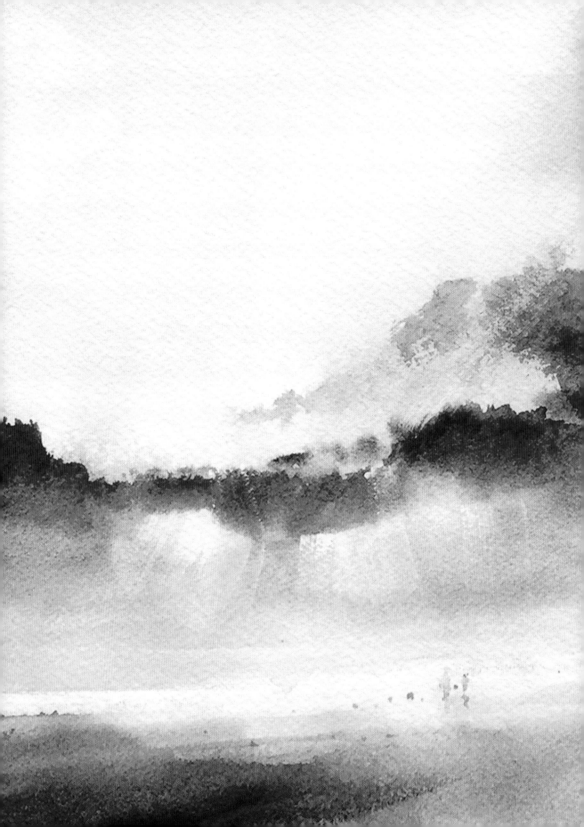

Applying your techniques

The basic techniques outlined in the previous chapter relate to paint application and the technical aspects of using watercolour. Being able to apply those techniques to specific types of imagery is what makes the difference between a beginner and an experienced watercolour artist. In this chapter, you will learn how to take those basic techniques a step further by rapidly applying them to imagery such as painting waves, clouds and night scenes, as well as breaking down a painting into shapes.

Left **Pamela Harnois**, *Beach Walkers*, West Hollywood, California, USA, 2017. Knowing which technique to use when will help improve the intricacy and quality of a painting in a short amount of time.

What is plein air?

One of the greatest things about using watercolour is how incredibly easy it is to paint on the go. The supplies are transported easily, and not much is needed in order to create a successful and quick watercolour painting. Plein air is the act of painting outdoors; it is a lovely experience to be able to breathe fresh air while creating.

5 tips for plein air

Pack light For plein air painting to be quick and easy, the fewer materials carried, the better. Pack only the essentials such as paint, a few brushes, paper and water (see pages 14–15 for advice). Some artists carry a small transportable stool as well, so a place to sit and paint is always available.

Start with stillness Painting on location can be a daunting experience to begin with. To make it easier on the nerves, find a place that is quiet and calm. Do not focus on capturing people within the painting if that is too intimidating. Instead, paint one object found along a walking path or a small corner of a coffee shop.

Move to movement Once confidence has started to build, it will be much easier to create plein air paintings in more populated areas. Try branching out to a popular location in town and capture the hustle and bustle of the city. This is a great way to meet new people and make new connections through painting with watercolour.

Capture small moments You can capture a whole day by painting small. Try treating the pages of your sketchbook as a collage of moments. For example, if you are painting at a zoo, try capturing all the animals that you see throughout the experience.

Enjoy the day! There is nothing quite like painting outdoors, so do not worry about the perfect end product; focus on enjoying the time spent creating. Focus on the sights, sounds and smells! Often the memories of a day will become much more vivid if moments were captured through quick paintings.

Right **Nel Correa,** *Animales del Zoo de Madrid*, 2017.
Nel was able to capture the essence of a day spent at the zoo by breaking up his paintings into quick studies.

Below **Judy Salleh,** *Walking to Shelly Beach*, Sydney, Australia, 2018.
Imagine standing on the beach where this was created. The environment surrounding you while you create a fast plein air painting is half the fun.

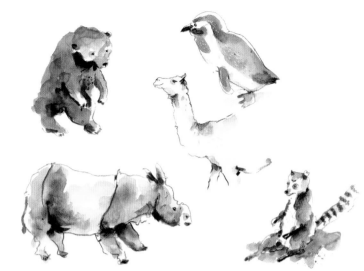

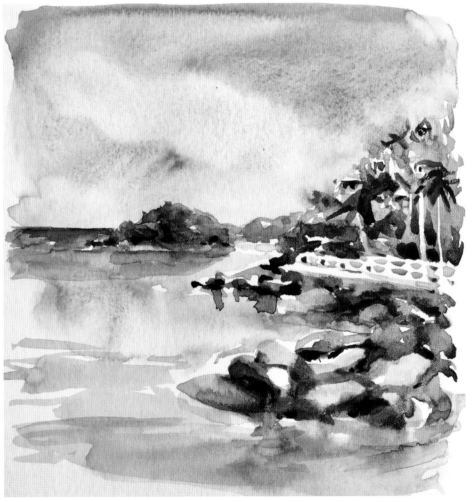

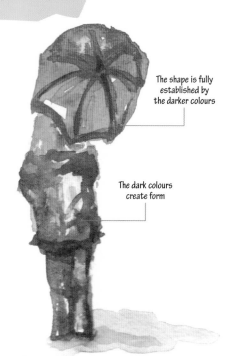

The shape is fully established by the darker colours

The dark colours create form

Left **Samantha Nielsen, *Red Umbrella*, 2017.**
The blotches of colour were painted first to map out proportions and where the imagery would land. Then the brush was used as a sketching tool and intense layers of pigment were added on top.

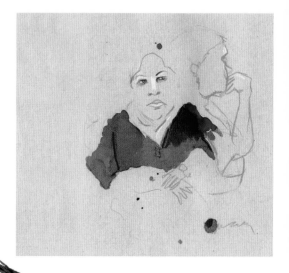

Above **Nel Correa, *Personas De Metro*, 2015.**
Nel used a coloured pencil to first plan out the proportions and facial features. A watercolour wash was added on top for a pop of colour.

Left **Jamie Kim, *Favourite Pet*, 2017.**
Try using ink to map out a painting before beginning. An ink outline can really spruce up the scene and make it more illustrative.

Create a base sketch

Being able to draw is not necessary in order to use watercolours successfully, but it is a skill that is helpful to work on as painting techniques are learned. The less energy you expend on drawing skills, the more you can devote to painting. That said, it is possible to learn both at the same time!

5 methods of creating a base sketch

Sketch with ink Even though these pages are filled with watercolour techniques, other materials can be used in learning to paint, such as ink! Start with a loose ink outline to map out where the paint will be applied.

Quick colour outline A great way to create a base sketch for a painting that blends in with the pigment is by using a coloured tool such as a coloured pencil. This allows for the composition to be created in quick layers, but the finished product still looks unified.

Brush sketch Perhaps other tools are not easily accessible, or you really want imagery that focuses on pure watercolour. In this case, try using the brush as a sketching tool. Lay down a layer of wash. When the wash dries, go back over with paint to create a variety of line work.

Holding the brush Do not forget that to be loose while 'sketching' with the brush, the way the brush is held is important. Holding the brush towards the base of the bristles will make the line work tight, while holding the brush at the back will help loosen up the marks.

Map out colours Dividing different shapes and sections into colours is another way to sketch out ideas. Do not feel overcommitted to a certain colour palette; watercolour can always be layered if you change your mind. Just remember to paint from light to dark.

Finding a subject

A great way to improve your watercolour abilities quickly is by painting different scenery. The more variation in imagery, the more practice you get. This practice also helps you get comfortable with any scene before you, opening up doorways to exciting new pieces!

5 ways to find a subject

Capturing colour Try painting a subject that has an interesting colour scheme. Find something that is incredibly bright and bold. Next, paint a scene that has more neutral tones. Changing up the tone of the palette will help you develop your style.

Explore the 'everyday' A simple object or scene can quickly become a beautiful painting. Do not feel that the subject matter of a piece has to be complex and detailed. A cup of coffee or a small bouquet of flowers can be just as intriguing as a vast landscape.

Fast textures If you have been spending a lot of time painting flat or smooth objects, add variety to your subject matter by choosing objects that have texture. Painting animals and feathers is an easy way to learn the art of capturing texture.

Changing angles Really understanding a subject, its proportions and colours, comes from experience of painting that object. Pick an item and paint it from the side or back to learn more about its appearance. The item will not look the same when painted from a different angle.

Find the value Watercolour will be more engaging for the viewer if the subject has a range of different values. More variation between darks and lights makes for a dynamic watercolour piece. Try studying objects that have a stark contrast between darks and lights, as well as shadows and highlights.

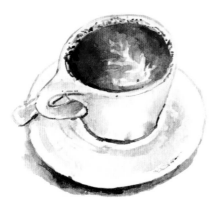

Left **Amara Strand, *Spanish Latte*, 2015.**
A latte does not seem like something that would be incredibly exciting to paint, but everyday objects can become more beautiful through the eyes of an artist.

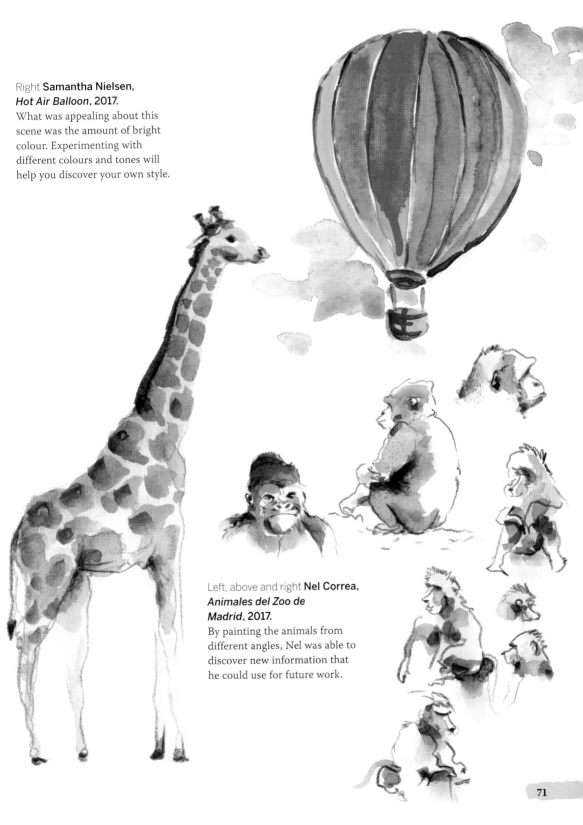

Right **Samantha Nielsen,**
Hot Air Balloon, 2017.
What was appealing about this
scene was the amount of bright
colour. Experimenting with
different colours and tones will
help you discover your own style.

Left, above and right **Nel Correa,**
*Animales del Zoo de
Madrid,* 2017.
By painting the animals from
different angles, Nel was able to
discover new information that
he could use for future work.

Right **Samantha Nielsen,** *Sketch First,* **Little Falls, Minnesota, USA, 2017.** By starting the first layer of the thumbnail sketch with loose lines in a small space, plenty of time was saved. In reality, this sketch took less than 30 seconds.

Thumbnail sketch

Paint added quickly

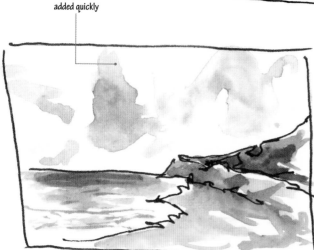

Left **Samantha Nielsen,** *Adding Colour,* **Little Falls, Minnesota, USA, 2017.** Notice that not all the value is perfect and the paint is relatively light; thumbnail sketches are for learning about composition, not creating the perfect painting.

Plan a composition to help improve a painting

Right **Samantha Nielsen,** *Floral Composition,* **2017.** Though a few minutes were spent creating this floral composition, in the end it saved time when creating the final piece.

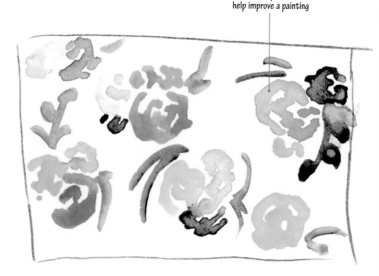

Quick thumbnail sketches

Planning and preparation (even for fast paintings) will help you create the best piece possible. Thumbnail sketches are used for creating small compositional ideas before tackling a painting. Use thumbnail sketching to learn about subject matter and create a more engaging piece of art.

5 tips for thumbnail sketches

Try a new perspective Just as painting on object from different angles helps with changing up the composition, painting a whole scene from a new perspective will help you discover the most interesting viewpoint.

Sketch small There is no point in a thumbnail sketch if it is not small. These preliminary paintings are not meant to take long, and the smaller they are, the less time they will take. It can also be less intimidating to capture a scene on a small area of paper. Use this opportunity to get comfortable with the subject matter.

Light and loose Do not try to be perfect while practising this technique. These miniature works of art are only meant to aid in decision-making and planning. Keep the painting and sketching light and loose.

Make it a habit When you get more comfortable creating watercolour paintings quickly, it can be easy to let go of the introductory techniques. Try to make thumbnail sketching a continued habit; even the best of artists still practise the basics.

Sketch to save time Even though starting out with a thumbnail sketch adds on a few extra minutes, these added minutes will save time in the long run. Thumbnail sketches are for making mistakes and learning what works and what does not, ensuring a successful final watercolour piece.

Break it down into shapes

Painting quickly is not hard; but sometimes the decision-making is.
Make the process of painting with speed easy by knowing how to break
down a scene into shapes. Often getting lost in the detail is what
causes an artist to spend more time on a work of art.

5 ways to break a subject down

Pick a portion Start with a small portion of an object and build to the whole. For example, do not get overwhelmed with how many different shapes make up an entire animal. Start with the head or the feet, and work from there.

Certain colours for certain shapes Try using specific colours for certain shapes. Pick three to four colours and create a whole scene using this limited palette. This will avoid overwhelming the viewer's eye, especially since the resulting forms will be simpler.

Avoid overworking Yes, there might be more detail than what is being captured, but in order to learn how to break a scene or object into shapes, practising that skill is important. Focusing on detail can be saved for later; for now, focus on shapes and only shapes.

Think big picture Take a step back to see the scene built up from basic forms. Look at the negative space (looking at the 'air' instead of the object) as shapes too. Painting the space around or within an object is just as valuable as painting the object itself.

Work out to in Start with an outline, then work inward towards the detail. If it is easier, you can also try building up an object as if it is a puzzle piece, working one shape to the next.

Right **Judy Salleh, *Parisian Facades*, Paris, France, 2016.**
Notice how only a few colours were used in creating this quick painting. Since there is not a lot of detail, using only a few colours helps the viewer piece together missing information.

Body drawn first

Legs drawn last

1

Above **Samantha Nielsen,**
Bug 1, 2017.
This bug is a great example
of building up a painting
piece by piece. The body
was drawn first, each piece
being added on one by one.

Below **Evelyn Yee,**
Elephants Dream, 2017.
Starting by painting a small
portion of an animal and
working towards the whole helps
with understanding the shapes.

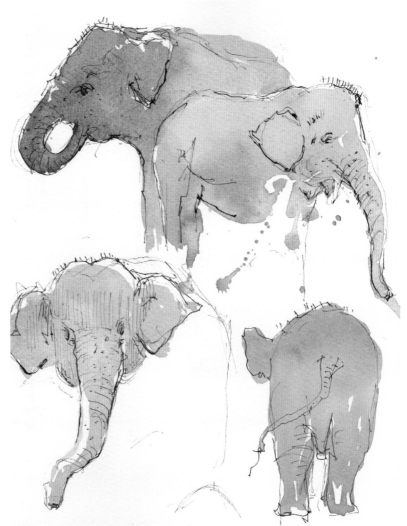

2

Keep the shape of the shadows
consistent with the object

Above **Samantha Nielsen,**
Bug 2, 2017.
Once the shapes were
established, colour was
added. The shape of the
shadows was consciously
thought about while the
paint was applied.

Above **Samantha Nielsen,**
Soft Edges.
This example of a soft edge was
created by pulling the watercolour
across the sphere with the brush.
Note that the cast shadow also
mimics the shape of the sphere.

Above **Samantha Nielsen,**
Hard Edges.
Hard edges on a painting are easy
– just try not to overwork the
paint! Even though this cube is a
simple shape on its own, this
technique can be applied to any
city skyline.

Below **Evelyn Yee,** *Geraniums,* 2017.
Look at the left side of the vase; the
white of the paper was left to create
a highlight. The cast shadow from
the vase and flowers is very deep
and rich; this creates depth.

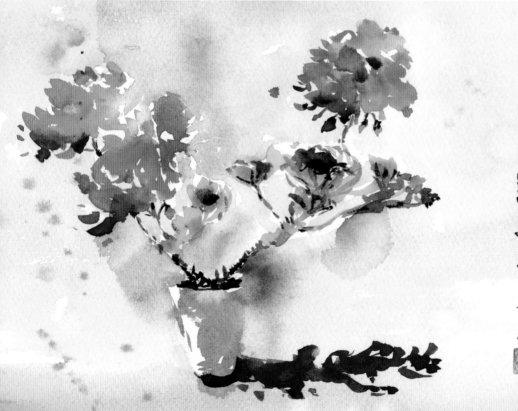

Using your light source

The importance of a light source cannot be overstated. The light source tells you where shadows and highlights should fall, lending life and depth to even the quickest of paintings. Do not let the light source go unnoticed, because this will make the difference between a good painting and a great one!

5 thoughts on light sources

Find the source of light Finding the light source is easy! Identifying where the darkest areas of a scene are as well as the lightest will tell you where the light is coming from. Do this before starting any five-minute painting.

Push the darks Adding dark value to a fast painting will bring it to life. It will also add depth to the quickest of paintings. If it is ever a struggle to find the dark values, squinting your eyes will help!

White for highlights While you can find ways to paint the white highlights – such as white paint or white pens – it is important to develop the habit of leaving the white of the paper to act as a highlight. Nothing will be as pure as the white of the paper.

Soft and hard edges Shadows and highlights can be developed gradually or quickly. Try both! Soft shadows can be created by gently pulling the colour across the page. Hard edges and strong values are achieved by painting the edge and leaving it be.

Just enough shadow Depending on the time of day or the light in a space, sometimes shadows and highlights will not be obvious, but do not let that lessen the quality of a quick painting! Even if the slightest of shadows can be seen, this is enough to tell you where the rest of the shadows and highlights should land.

Five-minute monochromatic

A watercolour painting can be exciting to create for many reasons. Sometimes the excitement comes from the colour or texture that is created; other times it can stem from the subject matter or the way the paint interacts with the paper. A great exercise to practise while learning how to use watercolour quickly is monochromatic painting – using different shades and tints of one colour.

5 notes on monochromatic

More or less water Vary the amount of water to make the pigment different shades. The more water that's on the brush, the lighter and more transparent the colour will be. Similarly, less water and more pigment on the brush will result in more vibrant and bold colour.

Create a value chart Working out how many lights and darks can be created from one colour can be done by making a value chart going from dark to light. The lightest side will need the most water, while the darkest side will need more pigment.

Swift shadows Creating monochromatic paintings that also look complete will depend on the use of shadows and highlights. Push the shadows to make the entire piece pop, and leave white spaces for the highlights. Try and shift gradually from light to dark.

Choose an intriguing subject Just because only one main colour is being utilised, it does not mean that a painting cannot still be exciting. Find ways to make the work exciting by choosing interesting subject matter.

Introduce some variety Once you have achieved some familiarity with monochromatic painting, try using two colours, assigning a different colour to each subject. Even though the painting in its entirety will not be monochromatic, working with one colour within each subject will help you push your skills.

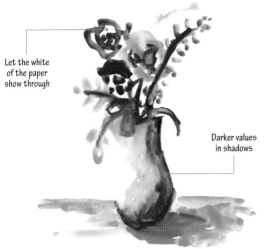

Let the white of the paper show through

Darker values in shadows

Above **Samantha Nielsen, *Purple Flowers*, 2017.**
The highlight on the vase was created by letting the white of the paper show through. The paint gets gradually darker purple towards the right side of the vase.

Below **Samantha Nielsen, *Blue Man*, 2017.**
Using more blue pigment and less water helped emphasise the darker shadows in the creases of his jacket and his scarf, as well as the shadow under his hat.

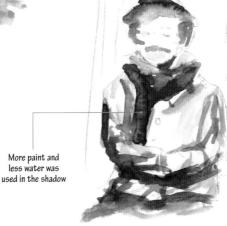

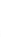

More paint and less water was used in the shadow

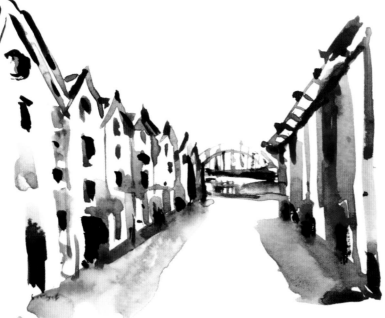

Left **Judy Salleh, *Sydney Harbor Bridge*, Sydney, Australia, 2017.**
Two different colours were used in this painting, but each section has its own monochromatic theme. Darker shades of blue and red were used in areas such as the windows and roof.

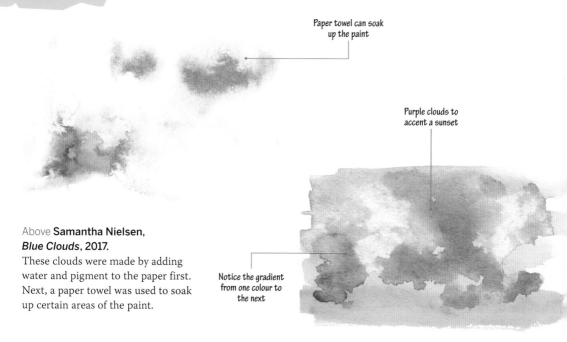

Paper towel can soak
up the paint

Purple clouds to
accent a sunset

Above Samantha Nielsen,
Blue Clouds, **2017.**
These clouds were made by adding
water and pigment to the paper first.
Next, a paper towel was used to soak
up certain areas of the paint.

Notice the gradient
from one colour to
the next

Above Samantha Nielsen,
Sunset, **2017.**
Sunset skies look great when a
gradient from colour to colour is
used. Instead of blue clouds, purple
helped add to this sunset theme.

Left Pamela Harnois, *Beach*
Walkers, **West Hollywood,**
California, USA, 2017.
Using a paper towel and pulling it
across the page while the paint is
still wet enough to soak up is what
creates the 'sunlight coming
through the clouds' effect.

Five-minute skies

Painting skies is a technique that can be used quite frequently.
It also incorporates many of the techniques already discussed, such as
wet-on-wet, graded wash and the lifting technique. Knowing when to use
which technique will help make a sky painting a success.

5 ways to paint skies

Wet the paper For most sky painting techniques, having the paper somewhat wet will be helpful. Unless you want very harsh lines on any edge where paint ends, slightly damp paper will make everything easier.

Lifting clouds Use a paper towel after painting the sky to create clouds. It is important to use the paper towel for lifting before the paint is dry. Keep the bottom part of the cloud darker, while gradually lifting paint off the top of the cloud.

Use a graded wash If the goal is to have a cloudless sky, one thing that can be done to make it more interesting is to use a graded wash. A completely 'flat' sky is usually less interesting than a sky that gradually goes from dark blue to light blue.

Create streaming sunlight When the paper is still wet, instead of gently lifting and dabbing areas of paint with a paper towel, try pulling the paper towel at different angles to suggest sunlight coming through the clouds.

Smooth gradient for sunsets Creating a sunset is easy enough. Select a few warm colours to create a gradient and make the transition between colours as smooth as possible. Add the clouds on top of the sunset sky, but instead of using blue or grey, try a purple to fit with the sunset theme.

Five-minute rocks

Painting rocks might not be something that many artists think about, especially as a subject for a quick painting. But it can be a skill that is handy for adding interest to a landscape or seascape. It does not take long to take a mundane subject matter and make it exciting!

5 techniques for painting rocks

Remember texture Some rocks are smooth, but a great way to paint rocks quickly and effectively is by incorporating texture. Think of all the dips and valleys that are on a rock. Incorporate that into the painting!

Use a card! On cold press or rough paper, a fast technique for texture is to scrape away paint with some type of rigid card (such as an old credit card). Create a base layer that is lighter than the top coat. When the top coat is close to being dry, use the edge of a card to scrape the paint, revealing the layer underneath.

Do not overwork it When trying the card technique, make sure to use as little water as possible. If the paint is too wet, the card will not do much of anything. Also learn when it is time to stop. Overworking the painting can cause the paper to start to fall apart.

Masking fluid highlights Try using masking fluid to block off areas where highlights are desired. Carefully planning where to place masking fluid will help you actively look for shadows and highlights.

Keep it fresh! Painting rocks on their own can make for a boring finished piece. Consider adding more scenery to liven up the five-minute technique, such as water or greenery.

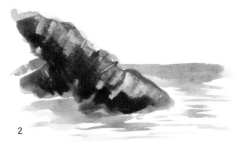

Above **Samantha Nielsen,**
Rock Layer 1, 2017.
This is the first layer of painting a rock. Burnt sienna was used for the base layer, and the paint was given time to dry before the second coat was added on top.

Above **Samantha Nielsen,**
Rock Layer 2, 2017.
After the burnt sienna dried, burnt umber was painted on top. Once the burnt umber was almost dry, a card was used to scrap away some of the paint, creating texture.

Below **Joseph Stoddard,** *Yosemite Valley*, Yosemite Valley, California, USA, 2016.
Small white areas have been left for highlights on the rocks. The greenery of the valley also livens up the rocky areas of the mountains.

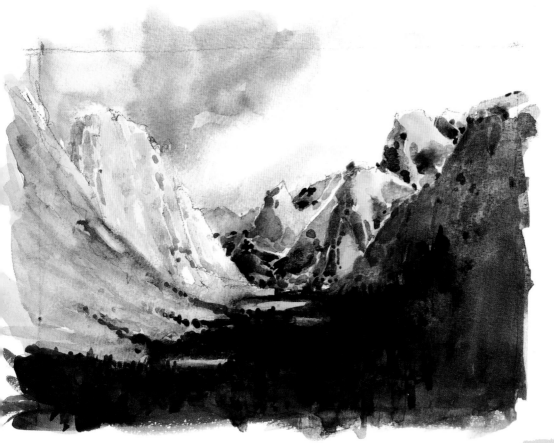

Right **Samantha Nielsen,**
Fading Pines, **2018.**
More water was used on the pines
furthest away to create a sense of
depth. Objects that are closer will
have more detail, while objects that
are further away will be diluted in
colour and have less detail.

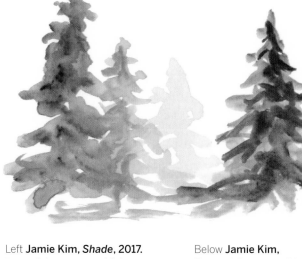

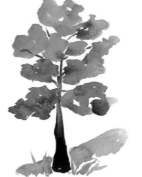

Left **Jamie Kim,** *Shade*, **2017.**
Jamie did not paint a blob on top
of a tree trunk; she left spaces
between the branches and sections
of greenery, allowing the tree to
look more natural.

Below **Jamie Kim,**
Tropical Greenery, **2017.**
A leaf study provides artists
with opportunities to gain more
knowledge of the subject matter,
by painting the basics that make
up the whole.

Five-minute trees

Trees can look drastically different depending on the time of year or the type of tree. They are also an element of landscape painting that can either help or hurt the overall piece. Painting trees is a skill that can be tackled in a short amount of time if you know how to begin and what to avoid.

5 ways to paint trees

Change up the shape Start by painting different kinds of trees. Each tree variety has a very different shape. Practising painting different tree shapes will help with tackling any type of tree.

Where are the leaves? To help achieve the proper tree shape quickly, start by examining where the greenery begins on the tree. Is the trunk quite long and tall, as in a palm tree? Or do the green parts meet the ground?

Beware of the 'blob' One of the easiest ways to paint a tree that looks wrong is by making the greenery seem as if it is just a blob on top of a trunk. Look at a tree in nature; there are little spaces all over where sky can be seen between the branches and leaves. Leaves and branches do not make up a completely solid form.

Concentrate on leaves A great way to study something large is by breaking it down into tiny sections. Instead of always painting a full tree, try breaking it down into the simplest form: leaves. Paint as many leaf varieties as possible and see how much can be learned.

Fade away forest There may be times when you are trying to capture an entire forest rather than just one tree. Achieve depth quickly by painting the trees that are furthest away much lighter than those that appear close. Remember, to make the watercolour more transparent, just add more water.

Five-minute water and waves

Water is a little more complex than it sounds, but there are plenty of techniques that are achievable in a short amount of time. Some of the variations found in water are waves, ripples, reflections and splashes. These techniques require few supplies and can be learned quickly.

5 methods for water and waves

Use a fan brush To capture rolling waves, use a fan brush and pull the paint down (starting from the highest part of the wave). Pull the paint about halfway down the length of the wave. This will show that the water is moving, but will also allow for variation in water colour.

Splashes with a sponge Next, where the wave meets the water there should be some splashes. A sponge dipped in watercolour will add the perfect texture for splashes. Use this sparingly, because if it is overdone the colour will just start to fill up the blank space; the end result will look heavy rather than light.

Easy water reflections Pulling a square wash brush from side to side instead of up and down is the best way to paint water ripples or reflections. Think of it as line work with the paint brush instead of painting a wash of colour. Break up the 'lines' to show the water rippling in different ways. Some should be short, and some should be long.

Make waves uneven When water splashes against something such as a rock, it is not perfectly round and even. A five-minute wave will look even better if the splash is uneven in both shape and intensity. If every part of the wave looks the same, then it is time to make a change.

Create ripples using masking fluid Another easy way to show waves in the distance is by using masking fluid. As when painting the water reflections, pull from side to side and make the lines short as well as long.

Right **Samantha Nielsen,**
Seagull, **2016.**
Leaving white spaces by using a small brush or masking fluid will help quickly imply reflections and ripples in the water.

Fan brush to create the top of the wave

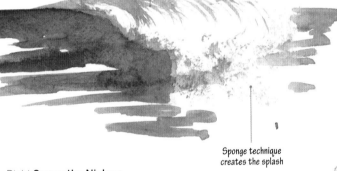

Left **Samantha Nielsen,**
Blue Water, **2017.**
A fan brush was used for the top of the wave, white space was left in the middle and a sponge was used to create the splash. Making the blue darker underneath the wave will give it the appearance of rolling over.

Sponge technique creates the splash

Right **Samantha Nielsen,**
Canal Lighthouse, **Duluth, Minnesota, USA, 2016.**
A square wash brush can be used to represent ripples on the water. Pull the brush from side to side, and break up ripples into long and short lines.

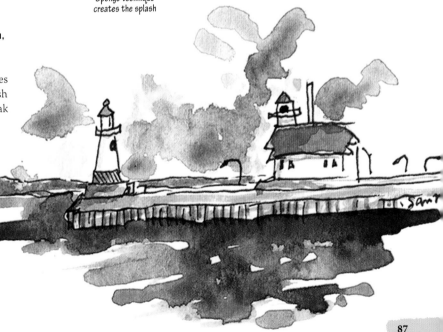

Right **Judy Salleh,** *Sheep, Sheep and More Sheep*, **Lake Taupo, New Zealand, 2016.**
The animals in Judy's painting turn this piece into more than just a landscape, giving the end result a more finished appearance.

Below **Amara Strand,** *Mount Fuji*, **Tokyo, Japan, 2017.**
The trees having more detail than the mountains in the background is an example of atmospheric perspective being put to use. The shadows are bolder and the colours are rich.

Five-minute landscapes

Landscapes surround us everywhere, and working out what to paint as a beginner can be a lot of pressure. Do not let that hold you back; set the brush to paper and get started! Painting landscapes can be a very freeing experience and there are many techniques to communicate your ideas.

5 approaches to landscape

Focus on one area Instead of trying to paint a large landscape, focus on just one area. Finishing a landscape in a short amount of time is perfectly feasible, as long as you do not try to include too much at once.

Add animals Try to switch up what a landscape looks like by adding simple animals into the scene. Thinking about these details makes a quick painting more interesting.

Fast impressions Creating landscapes in a short amount of time can be accomplished if you think about capturing the impression of the landscape rather than every single detail. Pay attention to the places where transitions between different types of land and textures are happening.

Remember atmospheric perspective Adding detail to objects up close, and reducing detail in objects far away, is an easy method for achieving the effect of distance known as atmospheric perspective. Colours will also be muted the further away they are.

Block it out Start a landscape by focusing on the shapes that are created. Where does the sky meet the land, and where do the trees meet the ground? Look for sections that are divided by variations in colour. Start with a base layer of these colours and build from there.

Five-minute cityscapes

The different ways a city can be captured are endless. As always, painting a city from different perspectives and viewpoints will open up new possibilities. Practising cityscapes will help you develop the skills for creating interesting compositions quickly and with ease. There are many parts of a city ready to be explored with watercolour.

5 ways to capture cityscapes

Paint the city from afar A city can be captured up close, but experiment with painting the city as a whole as well. Try painting the skyline quickly while focusing more on the shape of the buildings and less on details.

Consider using a reference photo It is not always easy to paint on location, especially when attempting to capture a city skyline or a busy street. In cases like this, try painting from a reference photo. Remember that the colour does not have to be an exact match, nor need the city be captured precisely; artists put their own spin on paintings all the time.

Capture city life A city is more than just buildings. To create a city scene that has some life, add in the essence of the city: its people! Capture what the city looks like during a morning or evening commute, as well as the general hustle and bustle of city life.

Different angles One city can be painted in many different ways. Paint different parts of a city, such as a single street with buildings up close or the city skyline. Capture skyscrapers or buildings next to the water as well as inland.

Look for landmarks Painting a cityscape in just five minutes can be an easier process if a landmark can be added. If you want the city to be quickly identifiable, your task will be made easier if you choose to paint some of the sites that particular city is known for.

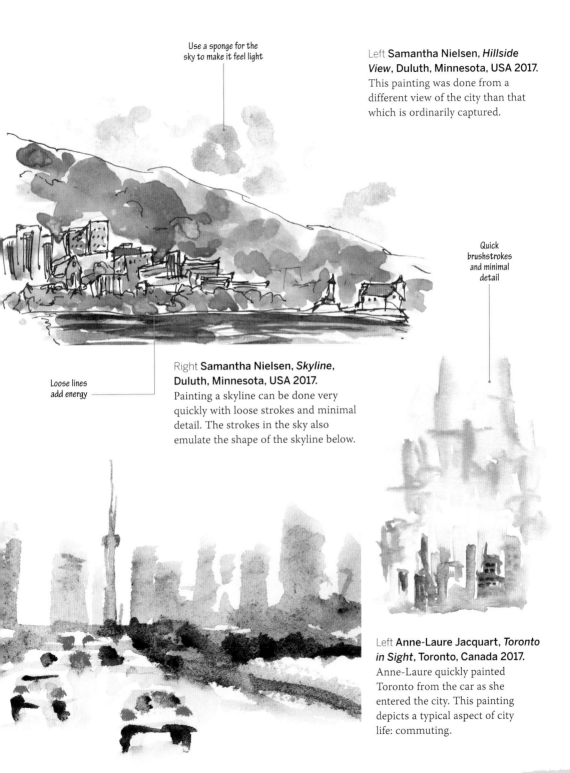

Use a sponge for the
sky to make it feel light

Left **Samantha Nielsen, *Hillside
View*, Duluth, Minnesota, USA 2017.**
This painting was done from a
different view of the city than that
which is ordinarily captured.

Quick
brushstrokes
and minimal
detail

Loose lines
add energy

Right **Samantha Nielsen, *Skyline*,
Duluth, Minnesota, USA 2017.**
Painting a skyline can be done very
quickly with loose strokes and minimal
detail. The strokes in the sky also
emulate the shape of the skyline below.

Left **Anne-Laure Jacquart, *Toronto
in Sight*, Toronto, Canada 2017.**
Anne-Laure quickly painted
Toronto from the car as she
entered the city. This painting
depicts a typical aspect of city
life: commuting.

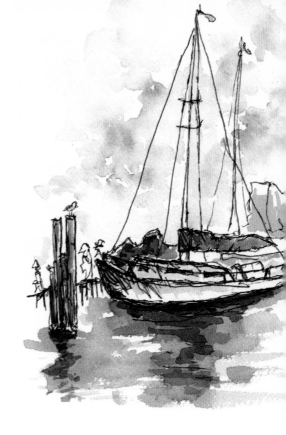

Right **Samantha Nielsen, *Sailboat at Applefest*, Bayfield, Wisconsin, USA, 2016.** Capturing the essence of what the water can mean to people is a fascinating part of the challenge of seascapes.

Left **Joseph Stoddard, *Macinac Island*, Macinac Island, Michigan, USA, 2016.** Joseph's artistic choice to leave the edges loose and uneven, framing the painting, adds more to this piece as a whole.

Right **Judy Salleh, *Malaysian Palm*, Charating, Malaysia, 2017.** Have fun with tropical water! With the combination of Judy's palm trees and tropical water, the viewer can feel the warmth pervading this piece.

Five-minute seascapes

Learning how to paint water is only the first step in painting a seascape. A seascape can encompass the entire scene including the shore, surrounding trees, boats on the water or even animals. Finding ways to make a seascape more than just water is key to creating a quick and successful painting.

5 tips for seascapes

It is more than water Do not think of a seascape as only a scene with water. So much activity can be happening in any seascape. Think about what types of objects you would associate with water, and try including them in the painting.

Is it tropical? Not all water is the same type of blue. Practise painting warm tropical seas or a bitter, cold lake. Colour can change the whole mood of the painting, so keep this in mind.

Change the horizon line As discussed in previous chapters, where the horizon line falls is important to the composition. Try to divide the paper into thirds visually, or have the horizon line high or low on the page. Deciding where the sky and water meet will influence how the painting looks.

Unfinished edges Try leaving the edges of a painting with an 'unfinished' feeling. By letting the paint gently taper off, a nice frame can be created around the painting by the paper.

What's the weather? Capture seascapes during different times of year. Try to paint a seascape with roaring waves as well as a calm sunset. Think about the colour of the water not being the same intensity throughout. Depending on the lighting, the area closest to the horizon line might appear darker than the water on the shore.

Five-minute floral patterns

Watercolour is the perfect medium for painting flowers.
Learning to paint flowers also presents great opportunities to practise
both loose painting and precise. Have fun with the colour selection
and create a scene that is reminiscent of spring!

5 methods for floral patterns

Look at lines and shapes Flowers are no more than lines and shapes. Look at each petal individually and see what shape is made overall. Try painting the stems very quickly with only a few simple lines. Add variety to the piece by changing the shape of the leaves.

Keep it loose Anything that comes from nature usually has qualities that can be painted freely. This is an ideal opportunity to test out splatter techniques! Keep the colours chosen for splatter similar to those already in the painting.

Try precision Even though flowers can look beautiful when painted freely, creating flower patterns with more precise lines and shapes isjust as effective. Let colours dry completely before adding more paint to prevent bleeding.

Merge background colours Try letting flowers that are part of the background blend with the background. Allow the flower petals to mingle with the background colours. A similar technique will be used to create pine trees in the fog in the next chapter.

Use warm or cool colours Colour selection is one of the best parts of painting flowers. Try sticking to either cool or warm colours and seeing what happens. Use a lot of pigment to make flowers that are strong and bold.

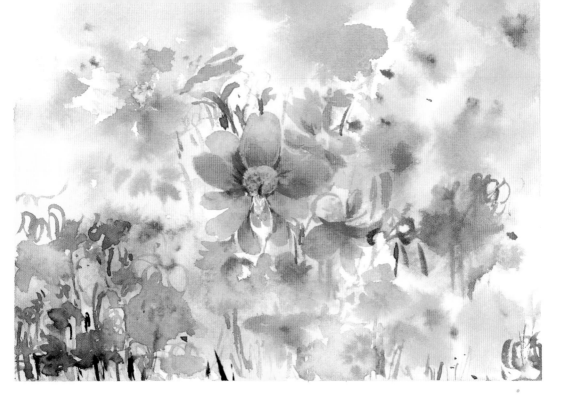

Above **Amara Strand, *Pink Florals*, 2016.**
Letting some of the flowers merge with
the background creates a captivating
composition. Amara really kept her
flowers loose and free.

Opposite **Samantha Nielsen,
Mini Bouquets, 2017.**
The precise, clean edges of these flowers
were achieved by not letting colours
blend together too much and allowing
the paint to properly dry before adding
more pigment.

Right **Samantha Nielsen, *Poppies*, 2017.**
Notice how these flowers are nothing
more than line and shape (and a little
bit of splatter).

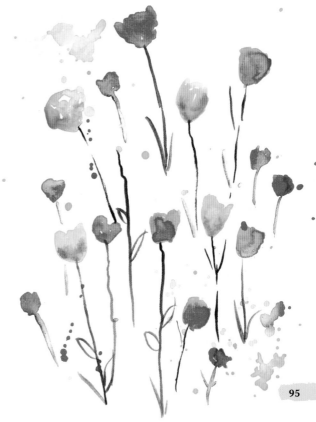

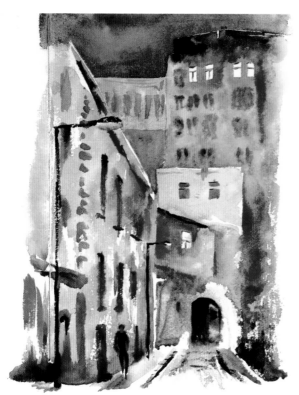

Below **James Richards, *Hurricane Irma View 3*, Lakeland, Florida, USA, 2017.** This painting uses all cool colours except for the dull glow of the street lights. The silhouetted trees give an indication of how dark this scene must have been.

Above **Anne-Laure Jacquart, *Manchester by Night*, Manchester, UK, 2016.** A painting at night does not have to feel dark – witness these vibrant colours! Emphasising the light of street lights and windows can complete a night scene.

Right **Judy Salleh, *The View from Sydney Observatory to Balmain*, Sydney, Australia, 2017.** Even though this painting has grey tones, notice how many of the silhouettes have a hint of purple. This keeps the painting fresh.

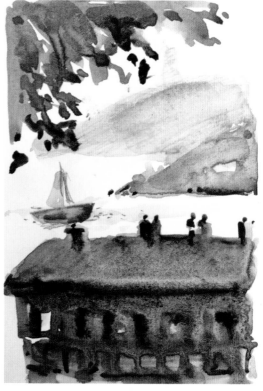

Quick ways to paint night scenes

If you do not understand how to use darker colours, painting a night scene can be a daunting prospect. Dark colours such as black and grey tend to dull a painting, but just because the night sky appears black, does not mean black actually has to be used! A night scene can be just as vibrant as anything else.

5 approaches to night scenes

Use cool tones One of the quickest ways to create a watercolour night scene is by using cool colours whenever possible. The sky will be deep, dark blues or purples. Shadows on buildings will be much cooler in colour as well.

Paint the silhouette Instead of painting objects such as people or trees in great detail, try painting just the silhouette. Standing in the dark, the human eye cannot see the colours of a tree, but a dark shadow or outline will be visible.

Grey tones Use grey tones sparingly. Even greys will have some other colours added to give the piece more life. However, painting a night scene in grey tones can be helpful when just starting out, because it takes out the extra element of colour and helps you focus on shapes and silhouettes.

Bright light Since everything is surrounded by dark, any shining light will become even brighter. Accentuate light coming from building windows or street lights to produce a painting that appears to be at night.

Avoid straight black Stay as far away from pure black as possible. Black paint will often 'deaden' and dull a painting. However, in those instances where black is needed, always mix a black paint instead of using it straight from the tube. A black mixed from multiple colours will be much more vibrant and appealing than a pre-made black.

Painting the four seasons

Changing up the colour palette and adding some variety is important
when painting the four seasons. Commonly, the focus when painting seasons
will be on landscapes, since those display the most obvious changes during
each season. However, do not be afraid to try out a cityscape and paint
the differences between winter and summer on the busy streets!

5 techniques for painting seasons

Think colour! Seasons can often be described
by their colour. Winter scenes will usually have an
emphasis on cool colours, while autumn might use
a lot of warm colours. Spring and summer are a mix
of both, but the green on trees will still feel warmer.

Season scenes The quickest way to articulate a
particular season within a painting is to think of
what imagery and scenes are associated with it. If
summer is the scene, what type of imagery comes
to mind when thinking of summer? Maybe being by
the water or eating fresh fruit!

Easy snow For winter scenes, snow is painted by
leaving some of the paper pure white, and adding
shadows with a very light (and transparent) purple
or blue. It does not take much colour to show the
shadows that land on the snow. You can give the
appearance of fog by using a fair amount of water
and letting the form of certain objects 'melt' into
the paper.

Paint it twice! A fun exercise would be to paint
the same scene but during different seasons!
Then spend time observing how the colour has
changed from one season to the next.

Go outside Why be stuck inside when you are
painting the seasons? Go down to the beach or
find a patch of grass in the local park and spend
some time practising those plein air skills while
also capturing the seasons.

Above **Samantha Nielsen,** *Single Birch*, 2017.
This birch tree was painted in the middle of summer.
Even though cool colours were still used, notice that
the grass still has a hint of yellow 'warmth'.

Above **Samantha Nielsen,** *Winter Fog*, 2016.
Creating snow or fog is easily done by adding water
to certain areas that have already been painted. Here,
the paint had not dried fully, so the edges of the trees
in the background were able to be softened.

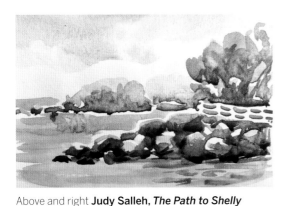

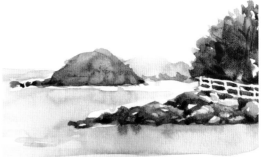

Above and right **Judy Salleh,** *The Path to Shelly
Beach 1 & 2*, Sydney, Australia, 2017.
Observe how much a scene can changed based on the
season. While the composition is obviously the same,
colour can be used in very different ways.

Right **Nel Correa**, *Personas de Metro*, **2017.**
These quick contour outlines capture the essence of these people without the artist having to spend too much time on detail.

Below **Anne-Laure Jacquart,** *Family from India*, **2017.**
By eliminating facial features and just focusing on the shapes, Anne-Laure really brings the attention to the sense of family and the colours of the clothing.

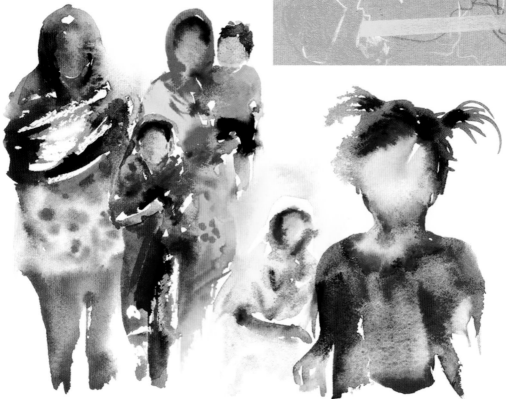

People and crowds

Painting people and crowds can be intimidating. Why? Because it requires being out in public! It can be a scary thing to paint when it feels like all eyes are watching, but with practice, this fear will fade away. Having to think on the spot will help improve speed and accuracy.

5 methods for people and crowds

Use fast contour Try sketching people while at a local coffee shop or on public transport by outlining their basic features. Force your brain to identify features by looking for shape and line direction instead of saying 'eye and nose'. Add splashes of colour to spice it up!

Paint them as outlines Perhaps people are in a scene, but they need not be the focal point. Paint everything else that is the focus of the piece and leave the people as black outlines. Sometimes leaving a watercolour sketch incomplete gives it more energy and interest.

Keep figures simple Eliminating specific facial features and focusing instead on body size and proportion is a fantastic exercise. Start by painting the general outline and build up parts of the body piece by piece.

People in motion Paint someone walking by without even looking at the paper! It might not turn out as the prettiest painting, but this is great practice to train the brain to paint what is actually being seen.

Favourite accessories One fun way to make painting people quickly an easy task is by picking out an accessory that catches the eye. Is it an umbrella or a bright coloured jacket? Perhaps the watercolour is not a perfect portrait, but the accessories that people carry can make it exciting!

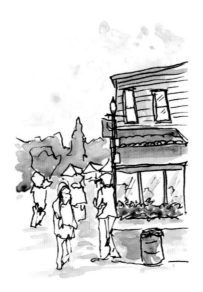

Left **Samantha Nielsen, *Bayfield Streets*, Bayfield, Wisconsin, USA, 2016.**
Choosing to leave the crowd as black outlines helped with communicating the focus of this watercolour painting.

Take it further

When you can apply basic techniques, it is time to learn how to fully exploit more than one technique in a painting, to explore the limits and possibilities of colour, and to develop an individual style. Continuing to implement and practise quick watercolour paintings is the best way to grow as an artist. This chapter will explain the extent to which colour can be pushed, blended and mixed; suggest how to incorporate different media into watercolour paintings, and give tips for continuing artistic growth.

Left **Pamela Harnois**, *Sun Flowers 3*, 2017.
Using new and unexpected colours, as well as choosing a different perspective, are great ways to investigate new styles and techniques.

Changing up the scenery

Keeping the scenery fresh keeps the painting process new every time. This can also help with finding inspiration. Sometimes painting the unexpected can turn into a whole new idea, so set a few minutes aside to experiment and paint something new. Creating a watercolour painting in new ways is also a great plan if you want to continue to develop your craft.

5 ways to change up the scenery

Zoom in! It is common to paint a scene from far away, capturing all the variation within one place, but how often do artists zoom up close to the subject matter? A whole new painting can come just from painting the details up close.

Different views How many different ways can one object be painted? Fill a page with one object from multiple angles to fully understand the subject matter. Try painting one object loosely as well as tight and precise. See what differences and similarities come from switching up the style.

Try something new If painting landscapes, cityscapes and seascapes is getting boring, switch it up and paint animals, plants or people. Even painting everyday objects can be exciting if it is a new experience.

Unusual locations Paint somewhere that seems unusual, like in the car! Finding new things to paint requires going to new locations. What can you see on a morning commute that you would not normally capture at home?

Change the size New imagery ideas could come from testing out a new size of paper. See what can be captured in less than ten minutes, and how big the painting can be! How much detail can be added to a small watercolour painting? Maybe try something more abstract by attempting to capture colour and movement.

Right **Samantha Nielsen,**
Succulent Set, 2017.
Just a few plants can be turned into several five-minute paintings. Practising these quick views also helps with planning a composition.

Right **Pamela Harnois,**
Sun Flowers 3, 2017.
Zooming in on these flowers
instead of painting the whole
field gives the viewer and artist
a different experience.

Below **Judy Salleh,** *Cow
at Kangaroo Valley*, 2015.
Painting animals instead of
landscapes or cityscapes is a great
way to change up the scenery.

Below right **Anne-Laure Jacquart,**
A Car from the Car, 2017.
Getting out of the usual scenery
can help an artist find new things
to paint. Anne-Laure decided
to paint in the car, and this is
what she saw.

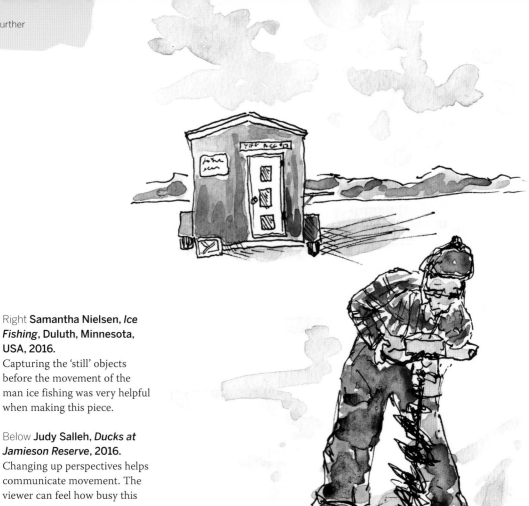

Right **Samantha Nielsen,** *Ice Fishing*, **Duluth, Minnesota, USA, 2016.**
Capturing the 'still' objects before the movement of the man ice fishing was very helpful when making this piece.

Below **Judy Salleh,** *Ducks at Jamieson Reserve*, **2016.**
Changing up perspectives helps communicate movement. The viewer can feel how busy this scene was.

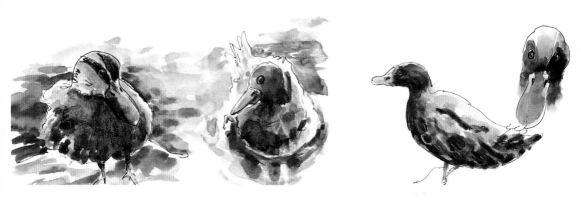

Capturing movement

If you can learn how to capture movement in a short amount of time, then painting objects that are still will also become much easier. Using watercolour to capture movement successfully has more to do with learning how to see than learning how to paint.

5 tips for capturing movement

Expressive strokes Keeping the brushstroke loose and free will naturally give a painting the feeling of movement. Pay attention to the direction of brushstrokes, as this communicates what type of movement is being captured.

Fragment or whole? Is the goal to capture a small fragment of the person or object in motion, or is it more important to capture the object as a whole? There is not a right or wrong answer, but decide this before painting. For beginners, it might be easier to focus on capturing just a portion of the movement (a person from the waist up, for example, or only half of an animal's body).

Snapshots of a scene If there is a lot of movement in one scene, think about how to capture all the different perspectives. Paint the object from close up, then far away. Think of capturing movement as taking snapshots of a scene.

Capture the stillness In every painting with movement, there are also portions of stillness. Focus on one thing at a time. Sometimes it might be easier to paint those 'still' objects before the movement; other times it will be quickest to capture movement first.

Paint 'blindly' Part of learning how to paint movement involves learning how to see. Try using one colour to paint (or even pick up a pencil and draw) a person walking by or leaves blowing in the wind. Attempt this exercise without looking down at the paper. Drawing or painting 'blindly' is a great way to study new objects and how they move.

Deciding on detail

When trying to work out what detail to include in a fast watercolour painting, it is important to take the time to make some decisions before the painting is even begun. Narrowing down the valuable detail can vary from piece to piece, but by knowing what opportunities to look for within imagery, you will have a much easier time making these choices.

5 ways to approach detail

Paint the big parts first Start off by painting the bigger and less detailed portions. Get colour on the page and then work towards the detail. Try to think of painting from big to small.

Tiny time There may be times you want to paint something in a short amount of time with a wealth of detail. So change the size! Instead of starting with the big portions, make the whole painting smaller. The less space that needs to be covered, the more time can be spent on the tiniest of details.

Leave it blank! Leaving some areas of a painting white will not only save on time but also make the areas of colour more exciting! Not every painting has to be finished to feel complete. Pick certain areas to leave white and spend more time adding detail instead.

What is important? Every portion of a watercolour painting should not have the same amount of detail. Decide which part of the painting should be emphasised and put more detail in this area. This will also save on time.

Break it up Since this chapter is all about taking it to the next level, there may be a time where you want to spend more than five minutes on a painting to really dive into detail. Not every painting needs to be completed in one session. Spend ten minutes a day on a painting, and that time will add up quick!

Above **Evelyn Yee**, *New Zealand Landscape*, Melbourne, Australia, 2017.
Leaving portions of this landscape white not only saved on time but also made the green of the hills stand out even more.

Right **Anne-Laure Jacquart**, *Loose Poppies Dancing in the Wind*, 2017.
Notice how the main part of the flower was created loosely and in a short amount of time. This allowed for more time to be spent on building up the value and detail.

Opposite **Samantha Nielsen**, *Butterfly*, 2018.
Time was saved here by painting the largest sections of the butterfly first – getting colour on the page and then leaving room for the tiny detail on the wings at the end.

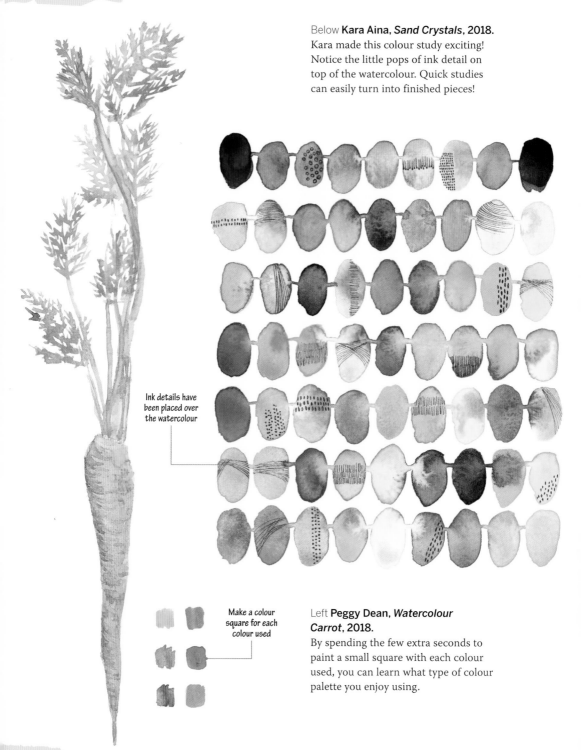

Below **Kara Aina, *Sand Crystals*, 2018.**
Kara made this colour study exciting!
Notice the little pops of ink detail on
top of the watercolour. Quick studies
can easily turn into finished pieces!

Ink details have
been placed over
the watercolour

Make a colour
square for each
colour used

Left **Peggy Dean, *Watercolour
Carrot*, 2018.**
By spending the few extra seconds to
paint a small square with each colour
used, you can learn what type of colour
palette you enjoy using.

Colour swatches

Sometimes colour can seem like such a basic concept; why spend what little time you have on colour instead of specific imagery? The answer is, the more you know colour, the less time you need to make decisions. Spending time getting to know each colour individually will help a watercolour painting sing!

5 colour swatch techniques

Get specific with colour There will come a point where you become very familiar with the colours you most often use. When this happens, take it to the next level and study specific sets of colours, such as warm and cool colours. See how many different blues and greens can be made by mixing different colours and different amounts of water.

Keep a colour reference Create a watercolour painting and keep track of the colours used. Paint a little swatch of each colour so that, as time goes by, this can become a point of reference when studying all the possibilities for colour. This is something that can be done quickly, and you can learn a lot from it!

Make a colour swatch Test out each colour by painting a quick colour swatch. Start with mostly pigment, then add water as the paint is pulled across the page. Take this study further by letting different colours mix together and seeing how they interact.

Speed up the process Some of this might seem tedious because these are techniques that do not result in an end product or finished painting. However, each of these techniques can be done in a short amount of time and will help speed up the overall painting process.

Have fun! Try adding some other media to the colour swatches to spice them up! This does not have to be a boring process – see what ink patterns or designs can be added on top of the colour for an engaging and abstract piece of art!

Left **Samantha Nielsen,** *Cool Colours.*
These colour swatches were created to see how each colour changes as it is diluted with more water. Focusing on only cool colours helped with understanding specific colour palettes.

Start a mixing chart

Becoming familiar with how colours mix is an easy and quick way to take watercolour to the next level. Anyone can use paint straight out of the tube, but there are so many more possibilities when you learn how to properly mix colours. Ten colours can quickly be turned into a hundred by creating a mixing chart!

5 thoughts on mixing charts

Why a mixing chart? A mixing chart helps you to understand the true possibilities for watercolour paint. It is amazing how many different colours can be made from a small selection of paints.

Make a grid Start a mixing chart by listing all the colours across the chart as well as up and down. Make sure the colours go in the same order, otherwise the mixing chart will not work.

Avoid equal mixes In order to see the full variety of mixable colours, add a little bit more of one colour than the other. For example, perhaps add more pigment from the colours that are listed vertically. This will prevent a mixing chart from being the same on both sides. Instead of 50/50 when mixing two colours, mix with 60 percent one colour and 40 percent the other.

A little study Spend time studying colour a little each day. Creating a full mixing chart can take hours, but experimenting with a few colours each day takes only minutes. Over time, mixing colour will become a quicker process and your paintings will appear more vibrant!

Use the chart! Making a mixing chart and then letting it sit on a shelf defeats the purpose. Apply the colours discovered on the chart to watercolour paintings! A fun challenge is to pick one or two rows of colours and create a painting using only those options.

Pyrrol red &
Hansa yellow

Deep scarlet &
Hansa yellow

Mayan orange &
Hansa yellow

Hansa yellow

Left **Samantha Nielsen, *Hansa Yellow*.**
This small mixing chart was created in only five minutes. Three different colours were mixed with about 60 percent hansa yellow.

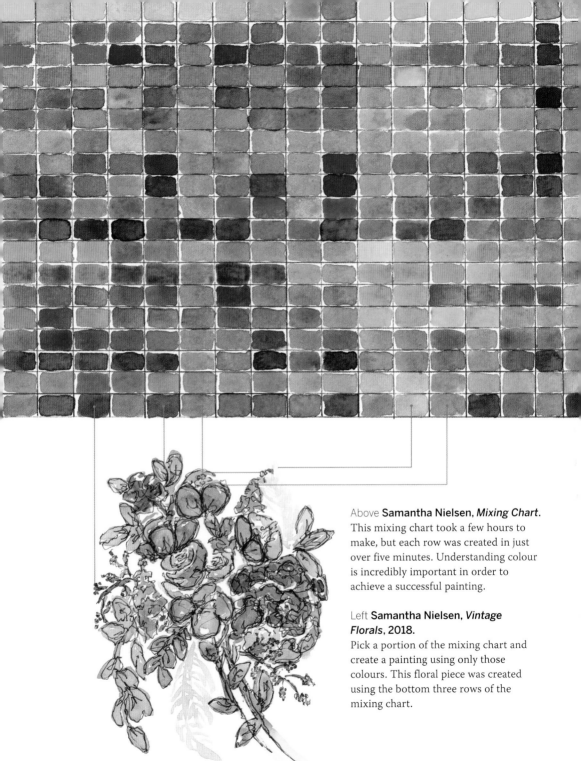

Above **Samantha Nielsen,** *Mixing Chart*.
This mixing chart took a few hours to
make, but each row was created in just
over five minutes. Understanding colour
is incredibly important in order to
achieve a successful painting.

Left **Samantha Nielsen,** *Vintage Florals*, **2018.**
Pick a portion of the mixing chart and
create a painting using only those
colours. This floral piece was created
using the bottom three rows of the
mixing chart.

Above Samantha Nielsen, *Colourful Cacti*, 2016.
Notice how on each of the cacti pots the light source is kept consistent. The left side is darker and the colour gradually gets lighter.

Right **Kara Aina, *Silence of Growing*, 2017.**
Darker colours will appear closer to the viewer. Because of this, Kara chose the boldest greens for the foreground.

Below **Amara Strand, *Kensington Market*, Toronto, Canada, 2017.**
Without the shadows that fill each of these structures, the viewer would not feel as though he or she could walk into these buildings.

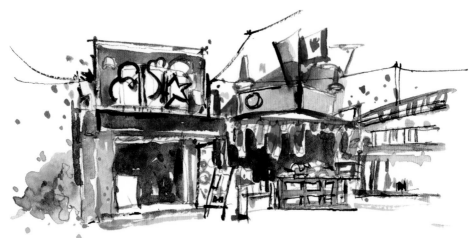

Creating depth quickly

Easy ways to create depth often relate to colour intensity, shadows and the amount of detail that is depicted. Think of it this way: when you look at the world, objects that are closer have more detail, while those further away have less. This is called atmospheric perspective and is the easiest way to create depth in a painting.

5 ways to create depth

Contrast shadows with highlights The shadows in a painting are so important! It is what grounds a work of art. Without adding shadows, any painting will seem flat, while adding shadows creates depth. Create a greater sense of depth by contrasting the shadows with the highlights.

Bold to the front Dark and bold colours will automatically feel closer to the 'front' (foreground) of the painting than light colours. The closer colours are, the more vibrant they appear. Viewing the world, it is easier to see bold colours when objects are closer; applying this to a painting will help create natural depth.

Keep light consistent One of the easiest and quickest ways to create depth is by keeping the light source consistent! If light appears to be coming from all different directions, it can be confusing and unrealistic.

Sharp or soft? Keep in mind that when things are closer they appear to have more detail in comparison to being further away. Objects in a painting that are closer to the viewer should have crisper and sharper edges. As objects get further away, the edges become less defined and softer.

Add dark last Remember to work from light to dark with watercolour. Even though the dark colours and shadows are so useful for creating depth quickly, save those steps until the end. It is easy to add more colour when needed, but harder to take away colour that is already on the paper.

Mixed media made easy

You do not have to stick to using one material. There are so
many materials that work great with watercolour and really add
texture and excitement. Test out using ink, coloured pencil or
even pastel with watercolour and see what happens!

5 tips for mixed media

Simple planning Because certain materials
react differently with water, take a moment before
beginning a mixed media piece to think about
whether watercolour should be the first, middle or
last step. Some materials will bleed when water is
added on top (which can be an intentional effect),
while waxy materials will resist watercolour.

Line and then wash Start out by using something
more controlled for line work, such as a coloured
pencil or marker. Try creating the form and basic
structure with the coloured pencil, then adding
washes of watercolour for the finishing touch.

Change the paper When using mixed media, test
out different kinds of paper as well! Some papers
will not hold as much water, but do not think of your
mark-making materials as the only materials that
can be interchangeable.

Washes and design Switch it up and paint a basic
flat wash to add some initial colour to the paper.
Next, add the details using other materials that will
stand out against the watercolour. Try something
that will add texture, such as crayon or pastels.

Be abstract Mixed media can become a great
place to play and experiment. Do not worry about
constantly painting something that is recognisable.
Instead, create an abstract work of art based on
shapes and design.

Opposite **Judy Salleh, *Shophouse
Window*, Little India, Singapore, 2016.**
Another great reason to test out mixed
media is that it allows precision to be
achieved more quickly. The little details
of the window could be done with
watercolour, but if you are short on
time, marker or ink would work as well.

Right **Peggy Dean, *Blue Flowers*, 2017.**
When painting fast, it is common to use very loose and gestural marks. Once skills are developed, it will become easier to keep the marks close and tight, as here.

Left **Kara Aina, *Mountainscape*, Salt Lake City, Utah, USA, 2017.**
Different techniques were used for each section of this painting, including using plastic wrap, wet-on-wet techniques and salt.

Experimenting with new materials

When you've learned the basics, it is time to push the limits! The best way to truly develop techniques and become quicker at watercolour painting is through practice and experimentation. There is not one correct style or technique to use within a painting; each has a place and it is up to you to decide how to use these materials and techniques!

5 ways to experiment

Many techniques Create a quick watercolour painting using as many techniques as possible. Paint a landscape or seascape that has different techniques within each section. Find ways to let texture and colour have a specific role within each piece.

Masking fluid as a tool Instead of using masking fluid as a tool to block off areas of paper that will be painted later, use it as a drawing tool! Make an outline around each object or segment and leave it as a border when the painting is finished.

Keep it tight It is easy to create a fast painting with loose, gestural marks. Once this skill has been developed, try keeping the mark-making tight and precise. Practising florals is an easy way to develop this skill in a short amount of time.

Mess it up Sometimes the greatest artistic accomplishments are achieved through learning from our mistakes. Once the basics have been developed, in order to take skills to the next level, you have to be willing to take risks.

Attempt new things Experimenting is about learning and being fearless. To truly learn the possibilities for watercolour painting, keep trying new things. Practise using these materials in new ways and do not get stuck in the same routine or confined to the same techniques.

Opposite **Claudia Savage, *Desert Statues*, Loomis, California, USA, 2018.** Instead of blocking out whole objects, Claudia used the masking fluid as a way to border each element.

Time is on your side

While five minutes might not feel like much time to accomplish anything in watercolour, the more time you spend practising, the easier this skill will come. Spend more than five minutes on the basics, then set a challenge of seeing how much can truly be accomplished in a modest amount of time. The results may be surprising!

5 thoughts on five-minute painting

Set a timer Experiment with what you are able to accomplished in five, ten and fifteen minutes. Paint the same scene or object over these differing times and see how the work changes. Setting a timer will help keep you accountable in this exercise.

Use other media You do not have to rely on only watercolour to achieve a realistic piece in a short amount of time. Think of watercolour as being the base, and add other media on top to capture the tiny details.

Big and bold Trying to complete a large painting in a short amount of time will be easier with bigger brushes! Do not hesitate in the mark-making process. Load that brush up with paint and fill the paper with energy!

Repeat shapes Create a painting by repeating similar shapes and scenery. Breaking a piece down into repetitive shapes is a great way to fill a lot of space in a short amount of time.

Stay positive! Starting out with any new material can be intimidating and daunting; adding on the skill of painting quickly can seem like too much to handle. However, bear in mind that each of these five-minute chunks of time will add up to hours and hours of practice!

Opposite **Samantha Nielsen,** *Yellow Banana,* **2015.**
This banana was created by laying a basic wash of watercolour down in the shape of the banana. The tiny details were then added with coloured pencil.

Above **Kara Aina,** *Éclats de Printemps,* **2018.**
Painting a larger piece in a short amount of time is easier with a bigger brush. Notice how many of the strokes are bold and full of energy.

Left Claudia Savage,
Scabiosas, **2017.**
Using masking fluid as a way to create a border is a great technique for taking a basic skill one step further.

Below Olga Flerova, *Summer Cat*, **2016.**
Olga took the basic concept of a watercolour bloom and turned it into an impressive painting.

Moving forward

You've practised new techniques and learned how to paint quickly. Now what? The quick watercolour paintings and the journey do not have to stop at the end of this book. Continue to conquer challenges and spend time with these materials; growth and technical skill will continue to come!

5 ways to move forward

Practise daily The best way to take a newly learned skill to the next level is by practising that skill! Set time aside each day to continue developing the art of watercolour painting. It only takes five minutes!

New imagery Try practising some of the skills that have already been mastered, such as the basic bloom or wet-on-wet technique, but change up the imagery. Find a new way to incorporate techniques that have been used in the past.

Enjoy the process Do not become overwhelmed with always trying to capture specific objects or scenery. Spend some time letting the paint speak for itself by painting something abstract. This will help you focus on colour and strokes instead of proportion and perspective.

Find your artistic voice Every artist has different memories and scenes that act as a source of inspiration. Study what other artists have created, but also spend time finding the individual artistic voice that each one of us has!

Commit to the journey Set big goals. What could you achieve by spending five minutes painting daily for a year? Five-minute watercolour is just the beginning. After perfecting this skill, see what can happen when you spend an hour on a painting. Speed and easy techniques are things that should always be revisited, but do not be afraid to take a painting to the next level.

Key elements

With every watercolour painting you create, there are certain techniques that will always be helpful. Keeping these key elements in mind while establishing quick watercolour skills will help make the process easier.

Brushes

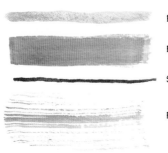

Round

Flat/wash

Small round

Fan

Have at least three to five brushes on hand. It is possible to create a watercolour painting with only one brush, but specific brushes have individual purposes. Different brushes will create marks that are wide, thin or full of texture.

Understanding colour

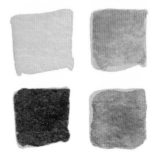

Mixing paint on the palette is important, but mixing paint on the paper by layering will also help with understanding how different colours interact on the page.

Brushstrokes

By painting in different directions as well as painting different shapes, you will find you quickly gain brush control. Try practising different brushstrokes to see the possibilities.

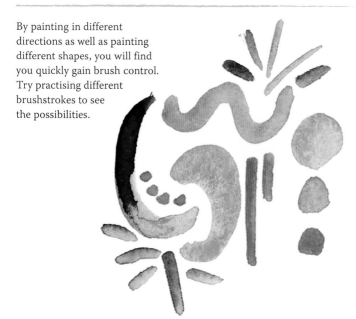

Value

Adding value (and shadows) to a painting is a quick way to add depth. This sphere would look completely flat without the shadow on the right side, as well as the shadow beneath.

Light to dark

Always work from light to dark when trying to increase colour intensity. Think of it this way – it is much easier to add more colour when you need it than to take away colour that has become too dark.

Cool and warm

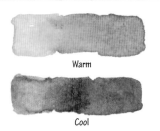

Warm

Cool

Understanding the different 'temperatures' of colour will help you create vibrant paintings. Experiment with placement of warm and cool colours within shadows and highlights. See how cool colours interact together as well as warm.

Layering

Besides working from light to dark to gradually increase colour intensity, it is also helpful when layering colour. By layering paint, some areas can remain softer or more muted, while others can become intense. Layering is helpful when creating depth or detail.

Simple shapes

Breaking imagery down into shapes simplifies the painting process and lets you work with one part at a time instead of becoming overwhelmed with the 'whole'. The more you understand how each image is made up of shapes, the quicker a watercolour painting can be completed.

Sketch it!

Learning to paint quickly is easier if you can also draw. If there is a certain form that seems more complex, try sketching it out before adding paint.

Paint it!

After sketching a form, decide whether the sketch should become part of the watercolour piece or not. If it should remain, add ink or another media so the lines become bold. This is a quick way to make a painting pop!

Index

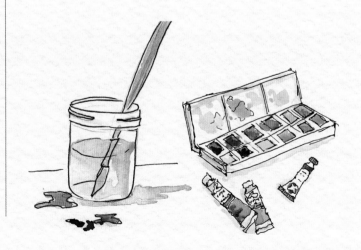

Acknowledgements

Author acknowledgments

I would like to thank everyone who has followed my urban sketching and watercolour journey, as well as the community of artists I have grown to know through different online platforms.

Thank you to everyone who has ever purchased my artwork, taken my Skillshare classes and supported me in this dream. Without your constant support this would not have been possible. You are one of the reasons I remain passionate about creating!

A special thanks to all of the artists who have been willing to contribute their incredible work to this book; you made this book even better! Thank you to Isheeta Mustafi, Abbie Sharman and Nick Jones: this opportunity has been one of the most incredible experiences, and with your constant help and feedback, you have made this process smooth as well as rewarding. Lastly, thank you to God for opening new doors, my parents and mother-in-law for being my most passionate fans, and my husband for believing in me more than anyone. Love you all!

Artist acknowledgements and websites

Kara Aina, 110, 114, 118, 121
www.instagram.com/kara.aina.art

Nel Correa, 20, 67, 68, 71, 100
www.instagram.com/nel_ilustrador

Peggy Dean, 110, 118
www.thepigeonletters.com

Olga Flerova, 3, 122
www.saatchiart.com/account/artworks/425625

Pamela Harnois, 64–65, 80, 102–103, 105
www.pamelaharnois.com

Anne-Laure Jacquart, 1, 28–29, 37, 40, 56, 91, 96, 100, 105, 109
www.watercoloursketching.com

Jamie Kim, 68, 84
www.instagram.com/inksnthings

James Richards, 96
www.jamesrichardssketchbook.com

Judy Salleh, 67, 74, 79, 88, 92, 96, 99, 105, 106, 117
www.judysalleh.com.au

Claudia Savage, 119, 122
www.instagram.com/cloudyartstudio

Joseph Stoddard, 83, 92
www.josephstoddard.com

Amara Strand, 20, 70, 88, 95, 114
www.amarastrandstudio.com

Evelyn Yee, 8–9, 75, 76, 109
www.evelynyee.com